the **digital photographer's** handbook

portraits

RotoVision

A RotoVision Book
Published and distributed by RotoVision SA,
Route Suisse 9, CH-1295 Mies
Switzerland

RotoVision SA, Sales, Editorial & Production Office
Sheridan House, 112/116a Western Road
Hove, East Sussex BN3 1DD, UK

Tel: +44 (0)1273 72 72 68
Fax: +44 (0)1273 72 72 69
Email: sales@rotovision.com
www.rotovision.com

10 9 8 7 6 5 4 3 2 1

ISBN 2-88046-656-3

Designed by S2 Creative Solutions

Originated by Hong Kong Scanner Arts
Printed in China by Midas Printing International

the **digital photographer's** handbook

portraits

Simon Joinson

CONTENTS

Introduction

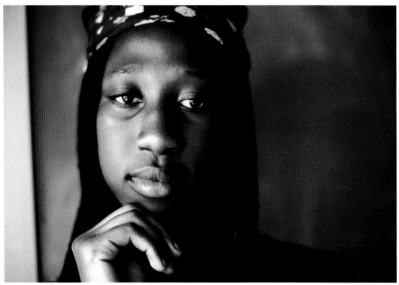

Within every man and woman a secret is hidden, and as a photographer it is my task to reveal it if I can.

Yousuf Karsh, photographer

Artists have been creating portraits in one form or another since the dawn of civilization. Where once a formal painted portrait was the preserve of the rich and powerful, the development of photography in the middle of the nineteenth century changed everything. There can be few people in the developed world today who have not been photographed at some time, or indeed who have never taken a picture of someone else.

Whether you are a photographic enthusiast or simply snapping family events, the infinite variety of faces, expressions and situations found in everyday human life mean portraiture can provide a lifetime of enjoyment for the photographer and the subject.

▲ **above: page 104**
Toning and adding grain/texture

▲ **above: page 40**
Fine tuned tonal control with Curves

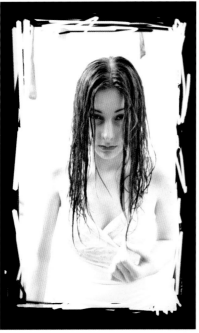

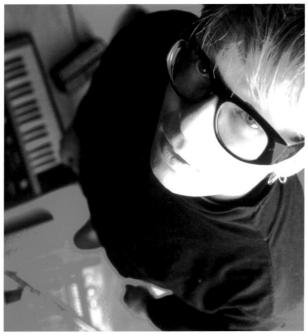

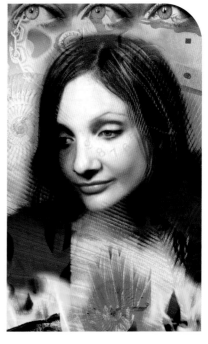

This is not a book about photography as much as a book about making great pictures using the uniquely rich potential of digital photography. Most of what happens in these pages takes place 'after the fact', when the photograph has been taken and transferred to the computer. Although the old adage that you can't make a silk purse out of a sow's ear still holds true, it is possible to seriously enhance portraits and make them more flattering, dynamic or arresting. Even the most mundane snaps can be transformed into exciting, unique portraits using the techniques described in the following pages. As well as producing images you can be proud of, with a little work you can create portraits that will not only please your subjects, they will be treasured for life.

▲ **above: page 66**
Reducing depth of field

▲ **top: page 44**
Cropping

▲ **above: page 94**
Torn edge effect

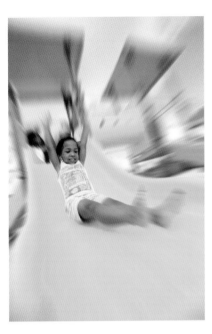

The major part of the book comprises a series of step-by-step projects designed to walk you through the most commonly performed correction, enhancement and manipulation tasks. The projects use Adobe Photoshop (versions 5.5 to 7.0), but can all be followed using similar applications, such as Paintshop Pro, Photo-Paint and Picture Publisher, all of which offer very similar (if not identical) tools to Photoshop itself.

Digital camera advantages

Digital cameras are uniquely well suited to portrait photography. For one thing, the lack of ultra-high resolution is rarely a problem. Low resolution cameras struggle to capture tiny details, but you don't need to be able to record the finest detail in a face to produce a beautiful portrait. In fact, most of your subjects would be quite happy to lose a few pimples and wrinkles!

Modern digital cameras have excellent lenses, meaning they are capable of producing remarkably sharp results. Despite the fact that many portraits are softened in some way, you still need the sharpest possible image to start with. The final advantage of shooting portraits digitally is the instant feedback offered

▲ **above: page 64**
Adding emphasis with
masked motion blurring

▲ **above: page 102**
Special effects filters

▲ **above: page 84**
Black and white
makeover

▲ **top: page 104**
Grain effects

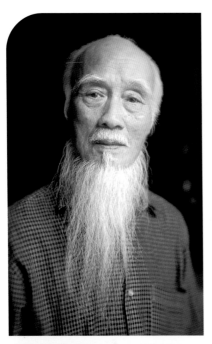

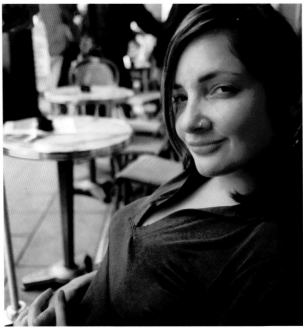

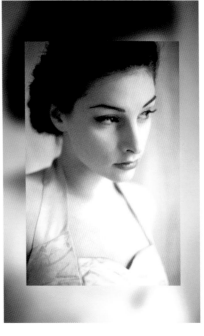

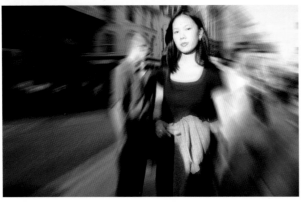

by the color screen. Being able to show your subject the results of a shoot immediately reaps huge rewards, relaxing them and encouraging them to experiment with more unusual poses and expressions. And because you have no film to waste you can shoot away at will, discarding poor shots as you go.

Digital camera disadvantages

If you are intending to print very large or shoot your portraits within a landscape, the lack of resolution of affordable digital cameras can become a serious limitation.

Any camera without a telephoto lens or some degree of aperture control will also limit your creative portraiture possibilities, but today's mid-range multi megapixel models should more than suffice and be capable of producing detail-rich prints of up to around 12x10".

The advent of the affordable high quality film and flatbed scanner has also helped open the door to digital imaging for those users who have no desire to abandon their film-based equipment.

▲ top: page 82
Color to mono

▲ above: page 72
Adding emphasis
with blurring

▲ top: page 98
Playing with color

▲ above: page 92
Creative borders

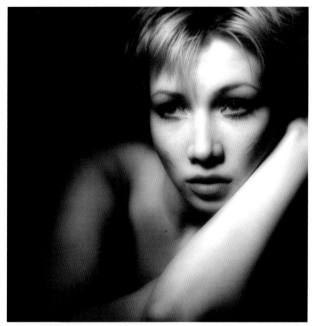

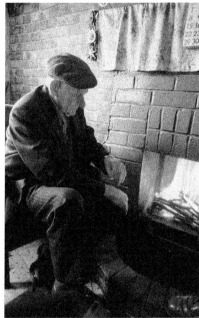

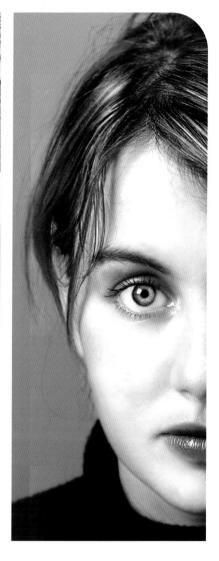

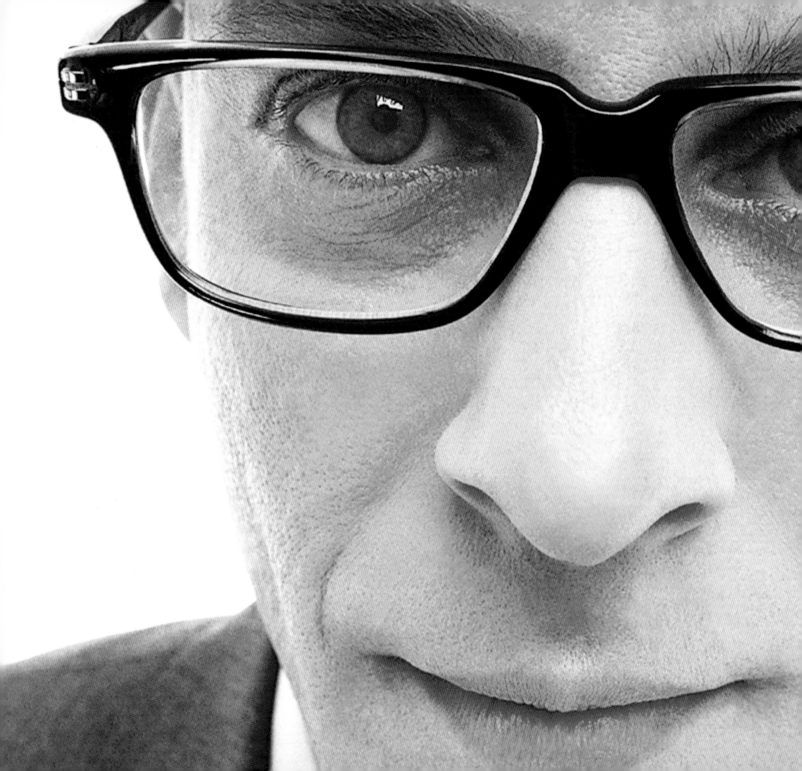

CHAPTER ONE

GETTING STARTED

The digital image

Shooting digitally or scanning existing photographs opens up a whole new world of creative possibilities. To get the most out of the hardware and software available, it helps to understand the basic theory behind digital images.

A digital image, no matter how it is generated, is made up of a grid of tiny squares called **pixels** (from picture elements). In the process of digitization, the scene (when using a digital camera) or photograph (when using a scanner) is captured using this grid, with the color from the original assigned to each corresponding pixel. The more pixels used, the more detail is captured and the sharper the image appears. The number of pixels in an image is a measure of its resolution - the higher the pixel count, the higher the resolution of the image.

The resolution also defines how large an image can be printed at 'photographic quality', which roughly translated means without the pixels being visible in the print at normal viewing distance. If you can see the pixels, the image looks 'blocky'.

At the heart of the digital image lies the pixel. The more pixels there are in an image, the more detail captured and the 'sharper' the result appears. These four shots show the effect of increasing resolution (clockwise from top left):

50x38 (1900) pixels
240x180 (43,200) pixels
640x480 (307,000) pixels
1200x1600 (1.92 million) pixels.

How many pixels do I need? Resolution is one of the most important concepts in digital photography. It defines the quality of the image (in terms of the level of detail captured) and limits the size that you can print the results. The rough rule with resolution is that - within limits - you can't have too much. A truly photographic quality print at 16x20" needs at least 3200 by 4000 (12.8 million) pixels - more than any consumer level scanner or camera can produce. Most digital imaging is therefore something of a compromise. If you never print above 5x7 " you needn't worry too much and even prints double that size are possible with affordable cameras or scanners.

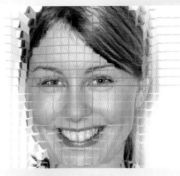

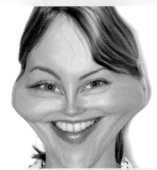

Shooting for digital manipulation

Shooting for digital manipulation When the digital photographer presses the shutter, it is only the start of the creative process. Once the image is in the computer, we can re-frame, remove unwanted elements, change colors and replace backgrounds.

So it is important to think ahead when shooting and look for the creative possibilities in even the most uninspiring portrait. Carry your digital camera with you at all times and take as many pictures as you can - you've no film to waste.

The beauty of digital photography is the versatility of the software and the almost infinite possibilities on offer. Whereas the traditional darkroom requires skill and dedication, digitally, you will be able to create amazing images within minutes. With practice and experimentation, it really is possible to transform the most mundane photograph into - if not a masterpiece - something worth printing.

The pictures on this page show the results of half an hour playing with the original digital camera shot (top left) in Photoshop, using quite basic techniques.

The digital process

The basic digital photography process consists of three distinct stages: input, processing and output. The processing stage is usually performed by computer, but some digital camera systems allow computerless printing via a direct connection to the printer.

The photograph is shot on film, whereupon it is processed and film scanned. Alternatively, prints are produced and scanned.

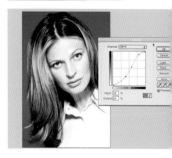

The digital camera captures digital photos, bypassing the scanning stage. The images are transferred to the PC via a direct connection or a separate card reader.

The processing stage can be as simple as opening the files and printing them, or it can involve a complicated series of corrections and manipulations.

Calibration Accurate color can be a real problem for digital systems, and monitor calibration is a vital part of ensuring consistent color throughout the process. Photoshop itself has extensive color control and calibration features.

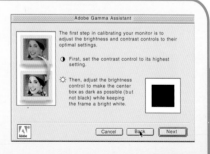

Output in the broadest sense includes emailing photos or posting them on the web, or simply copying them onto a form of storage (such as CD-ROM) for archiving or distribution.

By far the most popular form of output is still the print. Most home users will produce their prints with a color inkjet printer, some of which can easily rival conventional 'wet' photographic processes for quality.

While there is a massive range of hardware and software on the market, there are only a few basic principles to understand.

Digital images are simply photographs in a form that the computer can understand - they can be described using numbers alone.

The digitization process splits the photograph into a grid of pixels, and the position and color of each of these pixels can be described numerically, a process known as 'bit-mapping'. The size of the bitmap - how many pixels it contains - determines the resolution of the image and how much detail it contains.

In 24-bit color images (such as those created by digital cameras and scanners), the color of each pixel is defined as a mix of different proportions of red, green and blue (known in image editing as color channels). Each color channel can have one of 256 discrete values, from 0 to 255. The final image can thus

have a maximum of 256x256x256 (16.7 million) different colors within it. Applications such as Photoshop allow you to alter the color values of each pixel individually or en masse. Thus if you use Photoshop's color balance tools to change the overall color of a photograph, you simply alter the red, green and blue values of every pixel in the image by the same amount.

The computer monitor also uses red, green and blue dots to create a visual representation of your digital image on-screen. Monitors work in exactly the same way as televisions, although they are higher resolution (the dots are smaller and more densely packed) as they need to be able to display readable text at small sizes.

The output stage of the digital imaging process (which actually includes displaying it on screen) usually takes the form of a print on paper. Color printers use cyan, magenta, yellow and black inks to recreate each pixel in the image (you cannot use red, green and blue inks; see page 28 for more on this). The process of converting what you see on screen to what you get in print is where color accuracy problems are most likely to occur.

Mac or PC? Although both Apple Macintosh and IBM PC (Windows) systems are perfectly capable of digital photography work, there are differences. Macs are generally considered easier to use and certainly offer much better system-level color management, but Windows PCs are cheaper, much more widely used and have a much wider range of general purpose software available. If you are totally new to computers and are only really interested in digital imaging, I would go for a Mac, everyone else will probably be better off with an IBM compatible Windows machine.

19

The digital camera

Unheard of a few years ago, the digital camera is fast replacing its film predecessor for both professional and amateur use. The latest models offer a huge range of photographic features, and they often sport a decent lens too...

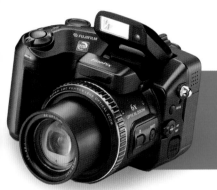

At the heart of every digital camera lies a sensor that converts light into an electrical signal. The most common type of sensor is the Charge Coupled Device (CCD). The CCD is made up of a grid of tiny photodiodes, each of which produces a signal whose strength depends on the amount of light falling onto it. Each photodiode together with its lens and associated circuitry is known as a pixel (from PICture ELement). When the digital camera takes a picture, the electrical signal from every pixel is recorded, processed and assigned a value between 0 (darkest) and 255 (brightest).

Since CCDs record only levels of brightness, they are actually color blind. To add color information from the scene captured, the sensor sits behind a mosaic of color filters, meaning each pixel records only red, green or blue light. Sophisticated in-camera processing then reconstructs the full color scene. Each pixel is assigned a color based on a mixture of red, green and blue light. Using 256 different levels of each of the three color components allows for over 16 million shades, more than enough to look 'photorealistic'. This is also known as 24-bit color (the R,G, and B components each using 8 bits of computer data).

The number of pixels on the sensor (and thus in the resultant digital image) defines the resolution of the camera. The first generation of consumer digicams offered images containing about 300,000 pixels, whereas 3, 4 and even 5 million pixel cameras are now common. Digital camera resolutions are often quoted as the pixel dimensions of the final image, rather than the total number of pixels therein. Thus a 1200x1600 pixel image comes from a 2 million pixel (or 2 megapixel) camera.

Virtually all digital cameras save the information captured in a compressed form (using a file format called JPEG) onto a removable storage card. JPEG compression has a small effect on the quality of the image, but does allow ten to twenty times more photos to be stored on each of the cards. The saved photographs are transferred to a computer for manipulation, printing or sharing via the internet.

Digital Video (DV) cameras now usually offer a stills facility, although it will not produce results as good as a dedicated digital stills unit.

typical digital cameras

webcams
The least expensive digicams: 1 megapixel resolution, fixed lenses, no removable media.

entry level
Ideal for beginners on a budget. Resolutions and specification vary, but zooms of more than 1.5 megapixels are rare.

Although digital cameras come in a variety of shapes and sizes, most share common functions and features.

Optical viewfinder

Zoom buttons

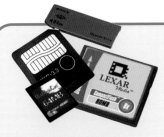

Built-in flash. Some cameras allow attachment of external flash units.

Shutter release

Controls for on-screen menus

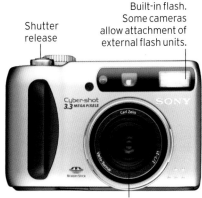

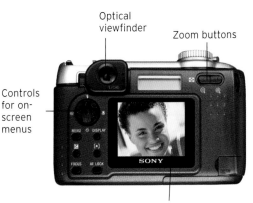

Built-in zoom lens

Color LCD monitor. Usually around 1.8" – used for framing and playback.

Most cameras ship with a variety of transfer and image enhancement utilities.

Camera features

Digital camera specification varies widely from very basic 'point and shoot' low resolution beginners' cameras and webcams, to highly sophisticated photographic tools with all the features and functions of a top level 35mm SLR.

All but the cheapest cameras have a small color LCD screen on the rear for previewing and reviewing shots (composition and playback) and a built-in flash. Most photographic enthusiasts will be looking at the mid to high end of the range and should aim for at least 2 million pixels, a 3x wideangle to short tele zoom and some exposure, focus and white balance overrides.

Image quality

For the photographic enthusiast, the quality of the final image is easily as important a factor as the design and specification. As well as resolution (which determines the amount of information captured), the performance of the camera's optics, exposure, focus and signal processing systems and the level of JPEG compression will all have an effect on the quality of the final image.

Most digicams attach to the PC via a USB connection

Storage and transfer

There are three commonly used solid-state (flash) storage formats: SmartMedia, CompactFlash and Memory Stick (unique to Sony).

A new format, the MultiMedia (or SD) card is also beginning to appear. There is not much to choose between the formats, although CompactFlash is used by the majority of camera models.

Cards are available in capacities ranging from 2MB to around 256MB. The bigger the card, the more pictures you can take.

CompactFlash Type II compatibility allows the use of IBM's MicroDrive mini hard disks. These offer huge capacities at affordable prices, but are more fragile than their solid-state relatives.

Most cameras use a USB cable to connect to the host computer, although the use of a separate 'card reader' is an increasingly popular option.

mid-range
The most popular type of digicam. From 1.3 to 3 megapixels, usually with a zoom lens and some level of control.

high end
For the more serious photographer – higher resolutions (3 million pixels and over) and a full range of controls.

digital SLRs
The most expensive digicams: usually feature removable lenses and offer the ultimate quality.

Lenses

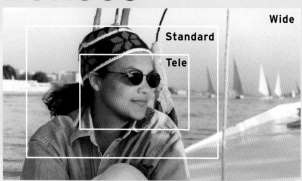

Standard
Tele
Wide

Most high end digital cameras sport some kind of zoom lens. The zoom allows you to change your angle of view by pressing the wide or tele buttons on the camera. The range of the zoom – from wideangle to tele – is usually quoted as either the 35mm lens equivalent (i.e. 34-102mm) or as a magnification range (i.e. 3x, where the telephoto is three times the focal length of the wideangle). Some camera systems allow the addition of extra wideangle or telephoto adaptors to extend the range.

Portrait photography is most commonly associated with the short telephoto lens. A long-ish lens allows you to fill the frame with a person's face, and the slightly compressed perspective is more flattering. Longer lenses also allow you to reduce the depth of field considerably, giving that classic 'fuzzy background' effect, as shown here. Try to avoid cameras with a fixed wideangle lens if you intend to shoot a lot of portraits, as these are much less well suited to photographing people.

Interchangeable Lens Digital SLRs If you feel restricted by the fixed zoom lens of a compact digital camera, you may be tempted to invest in a digital SLR camera with removable lenses. There are several reasons why this might not be sensible. Firstly, they are very expensive. Secondly, since the CCD inside the body is smaller than a 35mm frame, any lens used will see its effective focal length increased (by 50 to 100%), so true wide-angle photography is almost impossible. You would be better off initially, investing in a good 35mm scanner and sticking with film.

A wideangle lens can be useful for portraiture, but only if you are specifically looking for a distorted effect (as above). Group shots, on the other hand, need a wide lens to fit everybody in, and also come in useful when shooting people within a scene. Most digital camera zoom lenses are perfectly adequate for most portrait work, but look for the widest possible aperture to ensure total control over depth of field.

keep in mind
Unless you have access to unlimited storage cards, the 'uncompressed' option is best left for one-in-a-lifetime shots. Most cameras have a 'High' JPEG setting, which allows 10 times more pictures to fit onto each card with virtually negligible loss of detail.

Essential Accessories

Most compact digital cameras are not hugely expandable, but there are still plenty of add-ons and extras you'll need to consider. Make sure you carry plenty of spare batteries. If your camera uses standard AA batteries, invest in a few sets of Nickel Metal Hydride (NiMH) cells. These rechargeable batteries offer by far the longest life and do not suffer from the memory problems associated with many other types.

After power, the most common problem faced by digicam owners is running out of storage space. Although expensive, extra storage cards are essential. Don't buy the largest possible cards - you will be a lot less unhappy if you lose or damage a relatively cheap card. If you are out on a long trip, it may be more cost-effective to buy a cheap laptop computer and transfer the images at the end of each day. Most laptops have a PCMCIA (PC card) slot and this can be used to copy images directly off the camera's cards using an cheap adaptor.

Other indispensable accessories include a sturdy tripod and a good, fully weatherproof case for the camera itself.

Quality Settings
The images captured by a digital camera are usually saved using a file format called JPEG. JPEG files use a system of compression that reduces the amount of disk space the picture takes up by 'throwing away' some of the picture detail. JPEG allows you to choose the level of compression; more compression equals lower quality but smaller files. This is the basis for the 'Quality' settings on a digital camera. The 'High' setting is only compressed slightly, and the effect on the image is usually insignificant. Most high end cameras offer an alternative to JPEG, usually to save the image as an uncompressed TIFF. Although this does improve the quality slightly, it does produce enormous files.

Uncompressed
This TIFF image took up 5MB on the camera card. Despite the high quality, it is probably unsuitable for shooting in the field due to card space considerations. Using JPEG compression does not alter the resolution, it simply sacrifices some sharpness for the sake of file size.

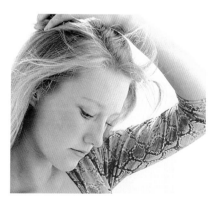

Highly Compressed
This 'basic' quality JPEG took up only 200KB (0.2MB) of space on the camera card, but the loss of quality is obvious. By using a lower level of compression, you can produce manageable file sizes with a negligible loss of quality.

Scanners

Many photographers' first taste of digital comes in the shape of a scanner. Affordable and easy to use, scanners also have the distinct advantage of allowing you to use your existing camera gear, as well as working digitally with all the photos you've ever taken.

Scanners use exactly the same technology as digital cameras, except that they move a narrow CCD sensor along a photograph, digitizing it one line at a time. This information is fed to the host computer where the scanner driver software processes it and constructs the digital image. Scanners attach to computers either via a USB or SCSI interface or, increasingly, via FireWire.

Resolution
Scanner resolution is measured in dots per inch, since the absolute number of pixels will vary according to the physical size of the original. Thus a 600dpi scanner can produce a 600x600 (36,000) pixel image from a one inch square original, whilst the same scanner will produce a 4800x6000 (28.8 million) pixel image from an 8x10 inch original.

Flatbed scanners are used to digitize prints and other reflective originals of up to A4 size. The prints are placed face down on a glass plate and the lid closed before scanning. Some models are capable of scanning transparent media (films), usually via an optional transparency adaptor.

Resolutions are usually from around 600dpi up to 2400dpi, and a wide range of models are available, ranging from the cheap to the really quite expensive.

High precision 35mm film scanners are capable of resolutions of up to 4000 dpi. They can usually accept 35mm mounted slides and film strips, and many offer an optional APS adaptor. With fewer models to choose from, starting prices are relatively high. Medium and large format film scanners are available, but are generally too expensive for non-professional use.

flatbed scanner resolution
Scanner resolution is sometimes quoted as a horizontal x vertical figure (i.e. 300x600 dpi). The first figure (horizontal) shows the density of pixels on the scanner CCD, whilst the second figure (vertical) is a measure of how far the CCD is moved between each 'line'. The horizontal figure is the truer measure of the 'optical' resolution of the scanner. Most manufacturers also offer much higher resolutions as an option, but since these are generated using interpolation, the extra resolution is simply 'guesswork'.

Scanner Driver Software

The software supplied with the scanner is nearly as important as the hardware in ensuring good quality scans. The driver software usually comes as a 'plug-in' for Photoshop or similar applications, and is accessed via the Import command (usually found under the file menu). Some scanners also ship with standalone software. Driver software varies widely, but the basic process is invariably the same: prescan, adjust scan settings and scan. The prescan allows you to define the area of the original you want to scan. As well as settings such as resolution and magnification, most drivers allow you to adjust the color, exposure and contrast of the image based on the preview image. The controls generally mirror those found in Photoshop, with the better software offering full levels, curves, color balance and sharpening functions. Most also offer a fully automatic 'idiot-proof' mode.

Scanning Tips

■ **Keep it flat:** The only way to get a sharp scan is to ensure the original is kept as flat as possible when scanning. This is especially true with flatbeds, where the weight of the lid alone may not be enough to hold things flat. For prints, try scanning with a large book on top of your original (leave the scanner lid open), and for films (using a transparency adaptor) a little scotch tape will hold curly originals in place.

■ **Keep it clean:** Keep both originals and scanning equipment spotlessly clean. A can of compressed air and a lens cleaning cloth should be all you need. Some film scanners now offer a hardware and software dust removal system – they actually work very well and are worth paying for.

■ **Don't go mad** with prescan color adjustments. It is very easy to mess up when working with the low resolution preview image and generally Photoshop's tools offer a finer level of control. Having said that, it is better to get the color, exposure and contrast more or less right at the time of scanning. Mastering driver software takes some time, so persevere.

■ **Resolution:** Try to scan at the correct resolution for your intended print size. Too high and you'll waste disk space and slow things down, too low and you'll get pixellated prints.

Software tools

The real power of digital imaging lies in the wealth of software tools available to subtly tweak or dramatically transform your photos in ways simply not offered by traditional methods.

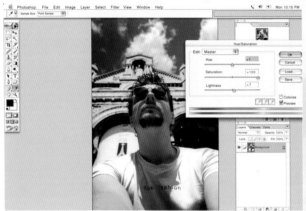

There are broadly speaking three different types of image editing software, although many products blur the boundaries and a few defy classification.

The first, oldest group of products is that built on the Adobe Photoshop model (above): powerful, hands-on image editors with myriad correction, distortion and manipulation tools and a wide selection of effects filters. Virtually all the projects in this book were created using Photoshop 6.0. Photoshop is the undisputed king of the serious image editors but it is too expensive for many home users. Fortunately, some alternatives come close to offering all the features of Photoshop in affordable packages. Applications worth considering include Jasc Paint Shop Pro (left), Corel Photo Paint, Micrografx Picture Publisher and Adobe's own cut-down versions of Photoshop (Photoshop LE and the far superior Photoshop Elements).

A second group of photo editing software has emerged since the arrival of affordable digital cameras and scanners. These 'project-led' programs are often very easy to use and tend to concentrate on making common tasks (color correction, printing and so on) easy, one-click tasks. The level of control and 'pixel by pixel' editing is often limited, but as a user-friendly and affordable entry point, applications such as MGI PhotoSuite are worth considering. Ultimately, however, there is a limit on the creative input you can have on the process, and you can soon tire of making calendars and birthday cards from your snaps. Most users will outgrow these applications and, as their interest in the creative side of

Photoshop versions
There are currently three variants of Photoshop on sale; Full Photoshop (currently on version 7.0), Photoshop LE (often given away free with scanners and digital cameras) and the relatively new Photoshop Elements.

Full versions of Photoshop (any version from 5.0 onwards) offer the most powerful tools, whilst LE is crippled somewhat by its massively reduced feature set. Elements offers much of the power of Photoshop 6.0 in an easier to use, friendlier package.

digital imaging develops, they will inevitably move on to more serious programs. The third type of software covers a wide range of products that perform one or more specific tasks. This includes 'funware' such as Kai's Super Goo (right), panorama creation software and template-based print programs (for creating cards, certificates and calendars). A separate group of 'mini applications' that run inside programs such as Photoshop (known as plug-ins) are available. These range from the useful to the frankly bizarre.

Albums & Slideshows

Albums & image databases
Keeping track of hundreds of digital images can be difficult. Applications such as Canto Cumulus offer powerful ways to catalogue and classify your ever growing image library. As well as basic views of thumbnails, multiple text labels can be attached to each image to allow for complex searches. At the other end of the scale, inexpensive 'image browsers' allow you to view the contents of a folder of images as thumbnails.

Slideshows
Sharing your images with other computer users is as simple as sending them a disk or emailing a selection of photos. It is also possible to create self-running 'slideshows' with complex fades and dissolves between frames and text captions. Some image editing applications offer this feature, or there are several standalone slideshow applications, the best of which is probably ScanSoft Kai's Photo Show.

Color printing

The complexities of the printing process could easily fill a book on their own, but a basic understanding of how the systems work is important for getting the most out of your digital images in print.

Digital cameras, scanners and monitors use a combination of red, green and blue light to create all the colors in the spectrum (RGB color). This is called an 'additive process' as the more color you add the closer you get to white. A wide range of colors can be generated in this way, although some very dark tones can be difficult – a computer monitor, for example, will rarely display anything approaching a true black.

Printers use a combination of cyan, magenta and yellow pigments in a 'subtractive' process (adding pigments 'subtracts' from white, resulting in a darker color). In theory, 100% each of the three pigments should result in black, but as this is rarely the case, a fourth ink (black) is added to produce the very darkest tones. This CMYK (K for black) process is the basis for all printing, from books and newspapers to home inkjets.

The four inks are laid down in patterns of tiny dots (the 'dots per inch' mentioned in printer specification) using a 'dither pattern'. This process lets some of the paper show through, allowing pale tones to be recreated (the inks themselves can only be laid down at 100%). At normal viewing distance the dots themselves are invisible to the naked eye and the eye 'mixes' them to give the impression of a continuous range of tones.

Photo quality inkjet printers add two extra inks (pale cyan and pale magenta) to reduce the visible graininess in pale pastel tones caused by the wide spaces between the dots.

alternatives to inkjet printers
Although inkjet printers are by far the most commonly used output devices, they are not the only technology available. Small 'postcard' printers using dye-sublimation or thermo-autochrome, offer high gloss, high quality 'fade proof' prints, albeit at a higher cost. You can now also take a disk or memory card full of images to a high street photo developers to have your digital photographs printed onto conventional photographic paper.

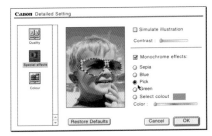

Virtually all home printing is done using a color inkjet device. These have developed rapidly over the last few years and can offer quality that rivals conventional photographic prints. Best for photographers is a 'photo quality' printer that combines high resolution with six color printing and advanced driver software.

Other printer technologies including Dye Sublimatio, are used in small postcard printers and offer excellent quality as well as direct print capabilities with some digital cameras.

The driver software provided with a printer is as important to the quality of the print as the hardware itself.

Using the best possible paper is essential to getting good results from an inkjet printer. There are plenty to choose from so it is worth experimenting until you find one or two you really like.

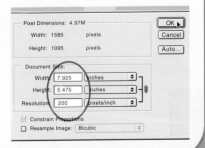

Some of the hundreds of different inkjet photo papers on the market. As well as the usual gloss and matt, there are a variety of special surfaces available, including cloth, watercolor paper and stipple.

Printing Tips

■ Print your images at between 200 and 300 pixels per inch (ppi) for the best possible quality on an inkjet printer. In Photoshop, use the Image Size command to change the resolution (making sure Resample Image option is off) as shown on the right.

■ Don't confuse the resolution of your printer, measured in dots per inch (dpi), with image resolution (ppi).

■ Most inkjet prints fade in direct sunlight, so keep copies of your digital images safely, that way you can reprint at a later date.

■ Always use high quality inkjet photo paper – anything else will reduce the quality of your output.

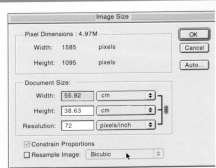

By altering the physical output size but not the number of pixels in the file you increase the print resolution to 200 pixels per inch – perfect for 'photographic' quality output.

The resolution of an image refers to the number of pixels, but print resolution is measured as a pixel density (pixels per inch). This file is 1585x1095 pixels, but the output resolution is set to 72 pixels per inch, making an enormous print (55.92x38.63cm).

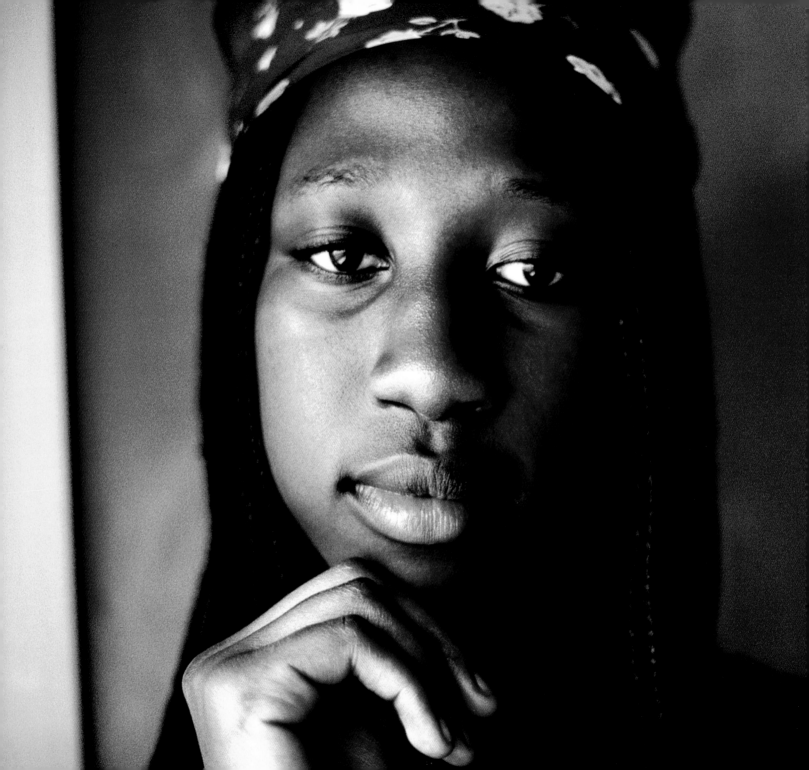

BASIC CORRECTIONS

Basic corrections

Most digital images need some basic corrections, from simple brightness and contrast adjustments, to color balance, sharpening and the removal of dirt and scratches on scans. The next few pages will look at how these are carried out.

manipulate it

02 After cropping (if necessary), the first job is to correct the exposure and contrast. We'll look at manual corrections from page 36, but for now we'll see what our image editing application can do. If the color looks right, but the exposure or brightness look wrong, choose Image > Adjust> Auto Contrast. If there is also a color cast, try Image>Adjust>Auto levels.

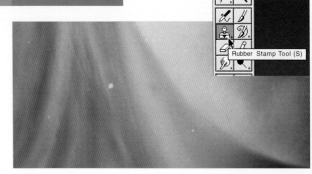

scan it

01 The basic principles on the following four pages apply equally to scans and digital camera shots, with the exception of the dust and scratch removal, which is only necessary when scanning your prints or slides. We'll start with a raw scan straight out of a typical flatbed film scanner with a transparency adaptor.

Image	Layer	Select	Filter	View	Window	Help
Mode	▶					
Adjust	▶	Levels	⌘L			
Duplicate...		Auto Levels	⇧⌘L			
Apply Image...		Auto Contrast	⌥⇧⌘M			
Calculations...		Curves...	⌘M			
Image Size...		Color Balance...	⌘B			
		Brightness/Contrast...				

03 Dirt is a common problem with film scanners, but can easily occur with flatbeds too. Take a look at this enlarged section from our original scan. The whole frame is covered in dust spots and scratches. Many applications offer automatic dust and scratch removal, but this will also remove fine details from the image. The tool we're going to use to 'rub out' the spots and scratches is the Rubber Stamp (a.k.a the Clone tool).

technical details
Hasselblad 500CM
80mm lens
Agfa negative film
Microtek ScanMaker 8700

 tools
Scanning
Cloning

 keep in mind
You can save yourself hours of retouching work by simply ensuring your originals are kept absolutely dust and scratch-free, and by cleaning your flatbed scanner's glass plate (use computer screen cleaner).

05 There is a definite knack to using the Clone tool. To define the source point (that's the pixels you are cloning from), alt-click. To paint with the source pixels, simply click and move the mouse like any other paint tool (without holding down the alt key). In the example below left, I alt-clicked in the position circled in white, then clicked where the yellow circle is and painted in the direction of the arrow, following the shape of the stray hair, ending up roughly in the position shown in the right-hand screenshot.

04 The Rubber Stamp acts in the same way as the paintbrush. You can change the shape and size of the brush itself by selecting any one of the presets in the Brushes Palette. You can also change the opacity of the brush from 1–100% (via the tool options palette, double click on the Rubber Stamp icon in the toolbar). For this purpose, leave it set to 100%.

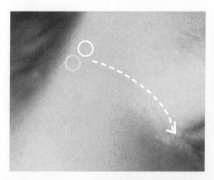 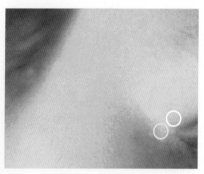

Cloning Tips

■ Use a soft-edged brush for a more seamless clone.

■ Do not place your source and target points too close – you will end up with a 'zebra stripe' effect by repeatedly cloning the same small group of pixels.

■ Make sure the area you clone from has a tone and texture that matches the target area.

In the above example , we need to remove the circled dust spot.

Using a lighter sample point results, unsurprisingly, in a pale blob.

Choose a point to clone from that is in an area of similar tone for a seamless result.

06 The final step in the cleanup process is to sharpen the image. Most scanners and virtually all digital cameras produce images that benefit from a little software sharpening. Although most applications offer a simple 'Sharpen' command, it pays to get into the habit of using 'Unsharp Masking'. Unsharp Masking (USM) allows you a high degree of control over how the image is sharpened with visual feedback in the form of a preview screen.

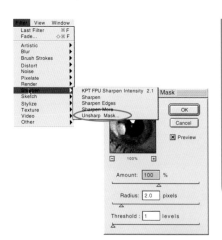

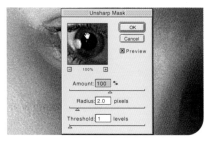

What is unsharp masking? Despite the rather confusing name, USM is a process that makes pictures look sharper. It does this by locating pixels that differ from surrounding pixels by a user-defined amount (the 'Threshold') and increasing their contrast by the 'Amount' you specify. The 'Radius' figure specifies how many surrounding pixels each pixel is compared with. This increases the contrast of edges, enhancing the appearance of sharpness.

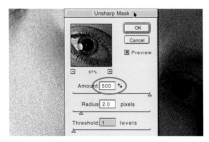

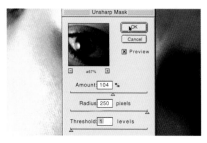

01 The figures you enter into the USM dialog will depend on three things: the resolution of the image, the quality of the picture (sharpness, noise, JPEG artefacts et cetera) and what you intend to use it for. Experiment with the settings to get a feel for what effect they have on the image. The Amount figure simply changes the strength of the sharpening. You will rarely want to go above about 120%.

02 The Threshold figure defines how different two areas need to be before being considered by the USM filter to constitute an 'edge'. The effect is to protect areas of continuous color from the sharpening. The Radius defines how far from each pixel the USM filter looks for an edge. Increasing the figure beyond about 50 results in contrasty images, and it is usually left under 10 unless you are after a special effect.

03 People generally find that their particular scanner or digital camera virtually always needs the same degree of sharpening, and therefore have at least a starting point. The figures shown in the box above - Amount 100%, Radius 2 pixels and Threshold 1 - are the settings I use for my 35mm scanner. My digital SLR (which has its own sharpening turned off) needs the Amount increasing to 200%.

Photoshop keyboard shortcuts

Zoom	spacebar and control/⌘
Rubber stamp	S
Change brush size	[(smaller)] (larger)
Color Balance	Control-B/⌘-B

keep in mind
Software sharpening always produces results that look much more marked on screen than they will when printed. Remember too that over-sharpened images look worse than soft ones.

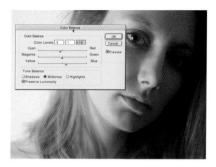

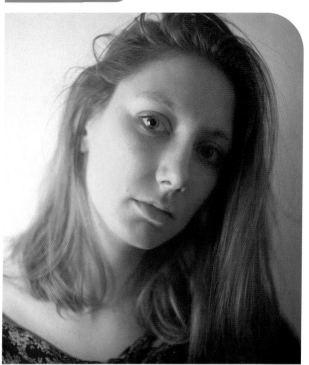

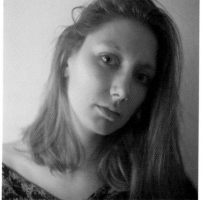

▼ Before After ▶

These basic steps – scan (or shoot digitally), crop, correct exposure, remove imperfections (from scans), sharpen and save – represent the 'bare essentials' of the digital process. Although some images will not require every step, it is a rare photograph that would not benefit from at least two of the stages. The difference even a couple of minutes work can make to the final print is remarkable.

Correcting digital camera images

- ■ Digital camera images are often flat and dull looking, but lurking inside the most unpromising shot is often a much more colourful, vivid photograph.

- ■ Use Levels or Auto Levels to correct the brightness and contrast and you'll see a massive improvement.

- ■ Take care when using Unsharp Masking on JPEG images: too much and you'll exaggerate the artefacts and fringes created in the compression process. This is the strongest argument for using the best quality setting on your digicam, or even opting for the uncompressed option, if available.

- ■ Photoshop allows you to create and save a series of corrections that can be run on a single image or a whole batch of files. These 'Actions' are useful if your camera consistently produces results that need the same corrections.

- ■ Digital camera files are inevitably created at 72dpi (screen resolution). Remember to resize to a higher resolution before printing (see page 29).

Using Levels

Auto correction functions and basic brightness and contrast settings are a good starting point, but an understanding of image histograms and Levels controls is essential for fine tuning your photographs.

input

01 We'll start with a typical digital camera image – lacking in contrast and slightly underexposed. Using the levels controls (image> adjust >levels), we can see from the histogram that there are no pixels with brightness values at the high or low ends of the scale.

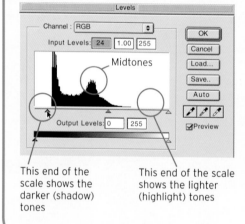

This end of the scale shows the darker (shadow) tones

This end of the scale shows the lighter (highlight) tones

Interpreting levels

This is the Levels dialog for the image as opened in Photoshop. The graph area is known as a histogram and shows the number of pixels at different brightness levels in the image.

The grey gradient at the bottom of the dialog shows the entire range of tones possible, from black (0) to white (255). Ideally we want to use as many of these tones as we can. In this example, the distribution of tones falls short at both the shadow and highlight ends of the scale, which explains the rather flat look of the photograph. We can use the Levels dialog to remap each pixel's brightness, so that the darkest point corresponds to black (0) and the lightest to white (255).

technical details
Olympus Camedia C-3030 digital camera
Adobe Photoshop 6.0

AUTO CORRECTIONS

Photoshop, like many high-end applications, offers various 'automatic' brightness/contrast functions. The first of these, Auto Contrast, attempts to perform the process described in steps 2-4 opposite. Auto Contrast (Image>Adjust>Auto Contrast) does not affect the color balance of an image. The second option, Auto Levels, also attempts to 'neutralize' the color of the image – in many cases, pretty successfully. Both functions need to be used with care, as they can clip highlights and shadows.

Left: Original image
Below left: Auto Contrast
Below: Auto Levels

 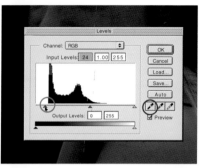
output

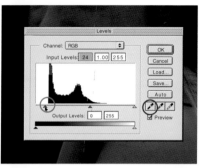

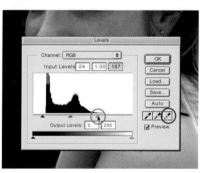

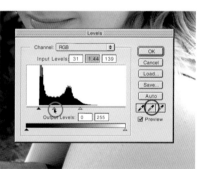

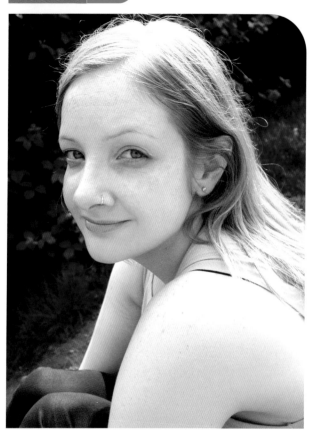

02 First we'll fix the shadows. Drag the black slider to the right until it is under the point where the graph first shows values (circled here in red). An alternative method is to use the black point eyedropper (circled here in blue) to select the darkest point in the image, although this can be hit and miss, and may also introduce a color change.

03 Now for the highlights. Move the white slider to the right until it is under the point where the graph first starts to rise. Watch the preview image as you do this, as you will probably need to go a little further to the right (some of the brightest levels will be specular highlights, and for this purpose, spurious). Again you can select your own white point using the eyedropper.

04 Finally the mid-tones. By moving the middle (grey) slider right or left you can darken or lighten the mid-tones without affecting the highlight or shadows (white and black points). Don't use the grey eyedropper (circled here again in blue) to set the grey point unless you want to change the overall color balance.

05 Our final result. You will need to experiment with the levels controls to discover exactly how to get the best results from your photo printer.

TIP BOX

■ When using Levels, turn off the preview (using the checkbox) and hold down the alt key whilst moving the white or black sliders to work in 'threshold mode', allowing you to see where the brightest or darkest points in the image are.

■ Make a selection first to apply brightness changes to a specific area of an image.

Selective exposure

Although most portraits can be fixed using the methods described on the previous pages, sometimes you will want to selectively alter the brightness and contrast of particular areas of an image independently.

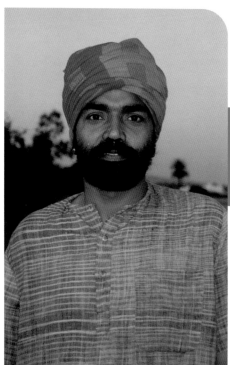

process

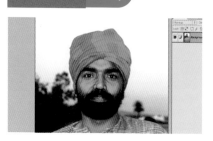

input

01 The most common reason for altering the brightness of areas in an image independently is to brighten the main subject (foreground) without washing out the background. By isolating the changes to the person only, we can keep bright blue skies and - to a certain extent - sort out problems associated with backlit and contre-jour shots. In this case, I simply want to lighten the main subject of the portrait whilst also darkening the attractive dusk sky.

02 If I adjust the levels of the entire image so that the face is brightened, the sky becomes almost featureless.

03 Adjusting the levels the other way - to darken and increase the contrast in the sky area - will also darken the subject unacceptably.

Layer	Select	Filter	View	
New				▶
Duplicate Layer...				
Delete Layer				
Layer Properties...				
Layer Style				▶
New Fill Layer				▶
New Adjustment Layer			▶	Levels...
Change Layer Content			▶	Curves...
Layer Content Options...				Color Balance...
Type			▶	Brightness/Contrast...
Rasterize			▶	Hue/Saturation...

04 I obviously need to apply different corrections to different areas of the image. I could do this using a selection, but here I'm going to employ a reversible method using a special kind of layer offered in many applications - including Photoshop - called an adjustment layer. An adjustment layer applies a tonal adjustment based on a layer mask, so you can use the standard paint tools to define the area to which the changes are applied. Choose layer>new>adjustment layer>levels.

technical details
Nikon F90X
Nikkor 28-105/ f3.5-4.5 AF-DIF
Nikon LS4000 scanner
Adobe Photoshop 6.0

38 Basic Corrections

tools
Levels
Adjustment Layers
Layer Masks

keep in mind
You can add a soft, feathered edge to masks by running the Gaussian Blur filter on the mask itself.

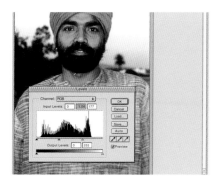

05 Click OK when the new layer dialog appears and you will see a standard Levels window. Adjust the levels to brighten the subject's face – a new layer appears in the Layers palette.

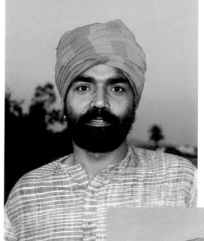

07 The shot on the left is the result of steps 3 to 6. The picture below has had another Levels adjustment layer applied to it, to increase contrast and reduce the brightness of the sky area.

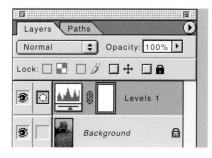

06 Working on the Adjustment Layer's mask (circled above in red), start to paint (using the paintbrush and a foreground color of black) over areas of the image that you don't want the levels adjustment applied to. White areas of the mask will allow the Levels adjustment to affect underlying pixels; black areas will mask the effect, leaving underlying pixels untouched. Double-clicking on the Layer icon lets you alter the Levels adjustments made in step 4.

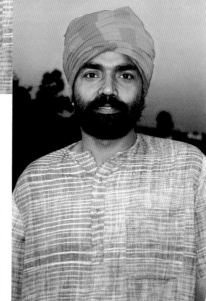

No adjustment layers? Adjustment layers are a quick and easy way of selectively applying tonal corrections, but not all applications have them. If working in such an application you will either have to create a selection before applying the Levels corrections or, preferably, create a duplicate layer, alter the Levels and add a layer mask. This allows you to go back and edit the mask you create should you spot any mistakes, and does not permanently alter any of the pixels in the original image.

▲ Using a selection

▲ Using a layer mask

Basic Corrections 39

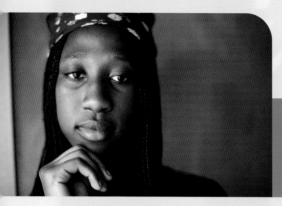

Curves

Often ignored by digital photographers because of the rather daunting interface, the curves controls are even more powerful than Levels for adding subtle or dramatic tonal changes to an image.

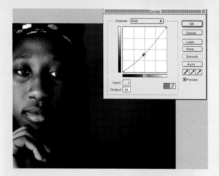

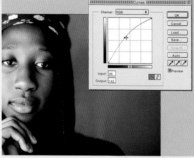

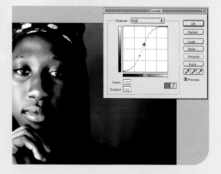

01 The curve itself is simply a graph that shows input (original brightness values, on the horizontal axis) versus output (the new brightness value, on the vertical axis). When you open the Curves window (image> adjust>curves in Photoshop), the graph is a straight line at 45°. Input and output values are identical.

By clicking on the line and dragging it, you add 'anchor points' used to change the straight line to a curve. Pulling the middle of the line down (as above) darkens the mid-tones in the image.

02 Conversely, dragging the curve the other way (up) lightens the mid-tones. Note that the highlight (white point) and shadow (black point) values are not changing in either case, as the line, though curved, still starts and ends in the same place. Although the 'Auto' button tends to be quite good at fixing exposure problems, using the curves controls to fix exposure is not as easy as using Levels (see pages 36-39), so I generally start in Levels for a rough fix before moving to curves for fine tuning.

03 By adding a second point to the curve we can start to make more complex shapes, such as this flattened 'S'. This shape of curve compresses the tonal range of the original (the angle of the straight part of the graph is more acute than when we started), and the curved 'tails' stop any abrupt cut-off of highlights or shadow areas. The net result is a higher contrast image.

technical details
Nikon F5
Nikkor 28-105/f3.5-4.5 AF-DIF
Nikon LS4000 scanner

tools
Curves

keep in mind
Curves, like many image adjustments in Photoshop, can be applied via an Adjustment Layer, allowing you to mask areas of the image you want to protect from changes.

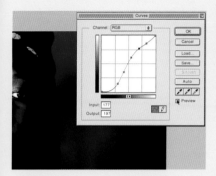

04 The beauty of the curve is that you can add points at will and still 'protect' certain parts of the image from any change at all by leaving that section of the line as a 45° straight section.

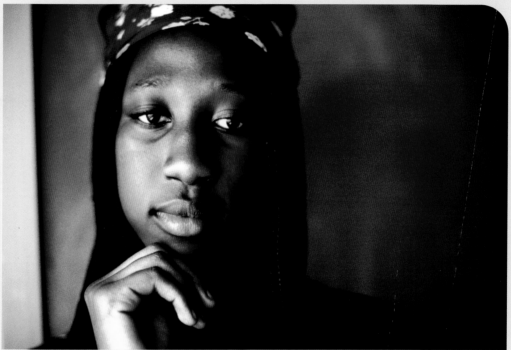

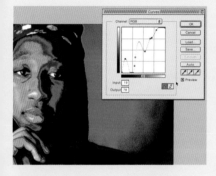

05 The key to using Curves creatively is experimentation. You can easily produce some wildly dramatic results by pulling sections of the curve at random.

06 The final result in this case is a relatively small change. The lower (shadow) end of the curve has been pulled down a little to darken the shadow areas. The mid-tones have hardly been changed at all (the middle part of the curve is almost as it was when the image was opened). The brighter mid-tones (or darker highlights if you prefer!) have been lifted a very small amount by adding the third anchor point and moving the curve upwards slightly.

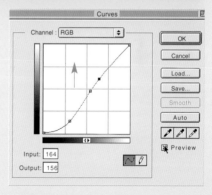

Fixing colors

Digital cameras have problems with mixed lighting. They also have a tendency to oversaturate the reds in an image. The result is skin tones that bear little resemblance to the original subject.

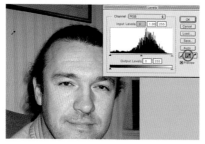

process

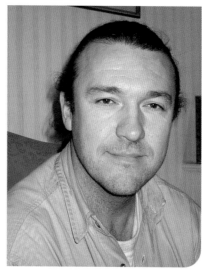

output

input

01 Digital cameras tend to oversaturate colors to produce 'vivid' results, but this, together with the often extreme color casts introduced by inaccurate automatic white balance, can often result in quite disturbing skin tones. Our example has a distinct, unflattering magenta cast. Fortunately, the image does have plenty of color and detail, so is well worth a few minutes' work.

02 Digital imaging applications offer many ways to alter the color balance of an image. My personal choice is usually the Levels controls. From here you can select a tone in the image that should correspond to a neutral 50% grey. Open the Levels dialog and select the grey eyedropper (circled above in red). Now click in an area of the image that should be neutral grey in color. You may need to click around the grey area a few times to find the right point, but the results are usually spot on.

03 And so, in three clicks we have totally removed the magenta cast and returned the greys in the image to neutral.

technical details
Canon PowerShot G2
Digital Camera
Adobe Photoshop 6.0

tools
Levels
Variations
Hue/Saturation

keep in mind
You may find you prefer the 'hands on' approach of the basic Color Balance controls, from where you can directly alter the amount of R,G and B in the image.

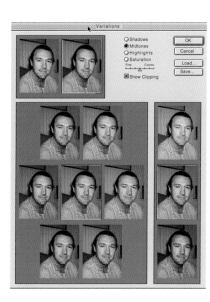

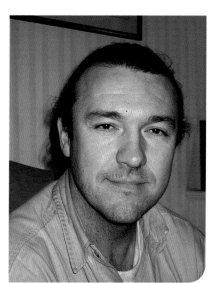

04 If there are no grey areas try using the Variations command (Image> Adjust> Variations), which offers an unique visual way to correct color problems (if monitor is well calibrated!).

05 The result I obtained from using Variations is slightly different from setting the grey point in Levels. But both are a major improvement on the original, and both are satisfactory.

Auto white balance in digital cameras rarely works in artificial light. The best solution is to set the white balance manually when you shoot, but it is possible to correct even quite severe problems in postprocessing.

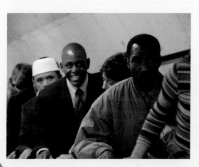

Hue & Saturation

One of the most common problems with digital camera portraits is oversaturation – particularly in the reds and magentas. This is disastrous for portraits, with even the palest skin tone looking like a side of rare beef.

The quickest solution is to reduce the overall color saturation using the Hue/Saturation controls.

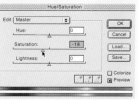

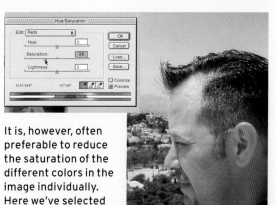

It is, however, often preferable to reduce the saturation of the different colors in the image individually. Here we've selected 'Reds' from the 'Edit' drop-down menu and reduced the Saturation to -36.

43

Cropping

It's the simplest of image enhancements, but it can also have a dramatic impact on the effectiveness of the portrait. The beauty of digital is, of course, you can do it all after you've taken the shot.

01 Many compact cameras lack the long lens and close focus needed for really tightly cropped portraits. Fortunately, even the most basic image editing applications offer cropping tools.

02 To use the crop tool simply click and drag a new frame, then press enter. It is always a good idea to save cropped images as a new file just in case you ever want to go back.

03 By rotating the image before cropping - or during - you can create a much more dynamic composition.

technical details
Canon EOS-1V & EF200 f1.8 LUSM
Nikon Coolscan LS4000
Photoshop Elements

tools
Crop Tool
Image rotation

keep in mind
When shooting portraits with a short lens, you may need to reduce the depth of field in postprocessing (see page 66).

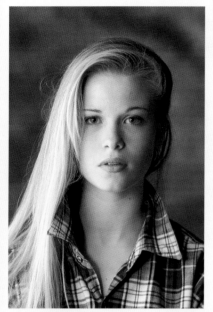

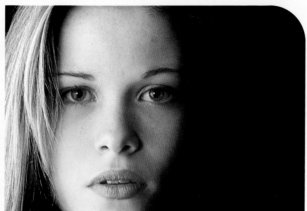

DIGITAL ZOOM

If your camera lacks a telephoto lens, the crop tool can offer a digital alternative. The effectiveness depends, to a certain extent, on having a high resolution and sharply focused original to work with.

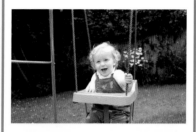

04 Changing the orientation of an image can completely transform the feeling of the picture – portraits do not always need to be vertical format. In this example, I've also darkened one side of the image and cropped very tightly for a starkly graphic effect.

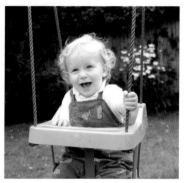

05 Creative photography is all about experimentation and stretching – or breaking – the rules. Even the most uninspiring original can be made more dynamic and impactful by careful use of the wide range of tools offered by an application such as Photoshop. In this example, the original had little to recommend – except perhaps as a photo for an identity card. By using a dramatic crop, then toning and increasing contrast the dull original becomes a stylish, contemporary portrait.

navigator

Removing blemishes

No one wants a portrait that shows your every spot, pimple and wrinkle. With a just a few simple steps, it is possible to produce photographic portraits that will win you friends for life...

01 If super models and cover stars can have their every blemish removed digitally, why not the rest of us? For our example, we'll use this portrait of a teenager - an age when looking good is more important than anything, and when nature decides to play havoc with your skin.

02 In our example, the first step is to reduce the overall saturation of the image slightly (see page 43). If your portrait needs any color, brightness or sharpness corrections now is the time to do them - removing blemishes should really be left until last.

03 Spots, pimples and other minor skin blemishes are best removed by simply cloning over them using pixels from another part of the face. Although you can do this directly onto the image (as described on page 32), for more involved projects it makes sense to clone from the original image onto a new transparent layer. This ensures that if anything goes awry, you can easily correct your mistakes. To get started create a new blank layer above your original image.

technical details
Nikon F90X
Nikkor 28-105/
f3.5-4.5 AF-DIF
Fuji Provia 100

tools
Hue/Saturation
Layers palette
Clone tool

keep in mind
Remember that you can resample different areas and use different brush sizes to get the perfect result.

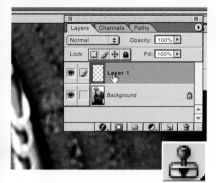

04 Make sure the new layer (here Layer 1) is active and choose the Rubber Stamp/ Clone tool.

06 Select a soft brush that is only slightly larger than the blemishes you are trying to remove.

08 If the tone and texture of the source and target match well, the blemish should be removed seamlessly.

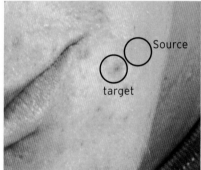

05 Most applications allow you to choose whether to clone to and from a single layer or all layers. We want to use all layers (in Photoshop the option is found in the tool options palette or toolbar, depending on the version you are using). Choosing to 'use all layers' means you can paint with pixels from the background layer (that's the one containing your original image) onto your new transparent layer (Layer 1). Thus, none of the detail from the original is changed permanently.

07 Alt-click (option click on a Mac) to set the point you want to clone from (the source), then paint as normal (without holding down the alt key) to cover the area you are cloning to (the target). Make sure you work at a pretty high magnification for total accuracy.

09 Address each blemish individually - don't try to paint over large areas or you will simply move the blemishes from one part of the face to the other.

navigator

10 If you look at the top layer (containing all the corrections) you can easily see how much cloning was done – and where. The advantage of working on a separate layer is that if you make a mistake you can simply remove the new pixels using the eraser tool.

11 Above is a screenshot taken at the end of the cloning. Don't get too carried away with this process – too much cloning can end up looking totally artificial. If you are totally happy with the blemish removal, flatten the image (merge the two layers) and save as a new file with a new file name.

12 Rashes and red areas (such as dry skin) can be toned down in a variety of ways. First, draw a freehand selection around the affected areas and add a large feather to the selection (around 20 pixels). Now use the Color Balance, Variations or Hue/Saturation controls to remove some of the red.

The eyes have it

The eyes are the most important part of any portrait, and a couple of minutes' work can add real sparkle.

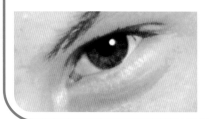

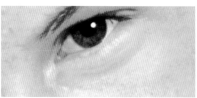

Remove dark bags under the eyes with the burn tool. Use a large, soft brush and a low exposure to build up the effect.

The same technique can be used to lift the eyes themselves. Work on both the whites and the irises, but don't overdo it or your subject will no longer look human!

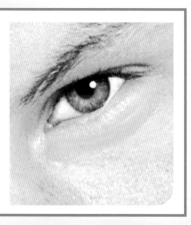

Photoshop keyboard shortcuts
Zoom spacebar and control/⌘
Rubber stamp S
Dodge Tool O
Change brush size [(smaller)] (larger)

tools
Rubber stamp
Color Balance
Dodge Tool

keep in mind
It is all too easy to go to far with this kind of alteration – the key to success is subtlety.

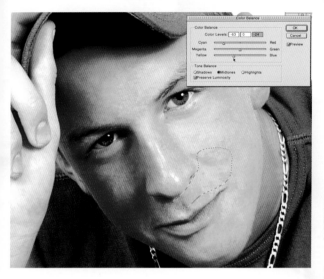

13 Here I'm using the Color Balance controls to match the area inside the selection with the surrounding skin tone. You will need to assess the results visually, but with a little care you can match the two areas seamlessly.

To finish the project I lightened the areas under the eyes, the whites of the eyes and the irises themselves using the burn tool (see box on the opposite page).

navigator

Cloning p32
Fixing colors p42
Softening/blurring p60

STEP-BY-STEP PROJECTS

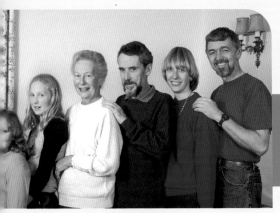

Backgrounds

Portraits always work better without distracting backgrounds, but unless you have a dedicated studio it can be difficult to avoid them. As ever, the digital darkroom has relatively painless solutions.

input

01 Shooting family portraits indoors presents some unique problems. Mainly, it is usually impossible to find a large enough bare wall to act as a backdrop. Try avoiding busy backgrounds as they will make the job of cutting out the subjects even more difficult.

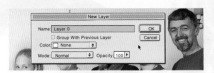

02 I'm going to use a Layer Mask to cut out the family. In Photoshop, convert the background layer (which cannot be masked) into a 'normal' layer. Double click on the thumbnail in the Layers Palette and click on OK when the window shown above appears.

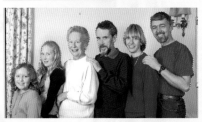
process

03 Now to make our initial selection. We need to select the entire background area – that is, everything except the family themselves. How you go about this will depend on the background itself; in this case I used a combination of the magic wand and magnetic lasso to create a rough outline. As we are going to create an editable mask from this selection, it doesn't matter too much if the selection is not perfect – it can be tweaked later.

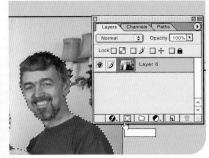

04 Turn the selection made in step 2 into a Layer mask (click on the Add a mask icon as shown above). If you are using an application that doesn't support Layer masks, use 'Quick Mask' mode or the 'paint on mask' option to clean up the edges of your selection (see steps 7-8).
 If your application doesn't support layer masks, simply delete the background after step 3.

technical details
Fujifilm FinePix 6800Zoom
Adobe Photoshop 6.0

tools
Layers
Layer Masks
Clouds
Lighting Effects

keep in mind
The more time you spend on getting the mask right, the more realistic the end result will look. Even small prints show the joins if they are not totally seamless.

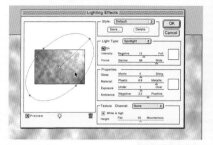

05 We now need to create a new 'studio like' background. You can make it as simple or be as creative as you want here, but the key is to keep the new background tonally similar to the original background; this will help disguise any problems with the cut out from step 2.

The first step is to create a new layer and place it underneath your original (masked) layer.

06 I'm going to create a new textured background using Photoshop's Clouds filter (Filter>Render>Clouds). This filter uses the current foreground/ background colors, so I've used white and a peach color sampled from the original background wall.

07 The new background will tend to look a little flat and artificial (mainly because it is!). To counter this, I'm using the Lighting Effects filter (Filter> Render>Lighting Effects) to add a little directional lighting.

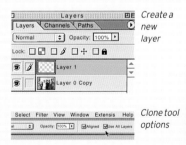

Create a new layer

Clone tool options

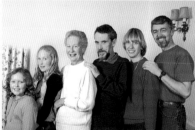

Cloning over the curtains

Paint away the background
An alternative method for removing backgrounds is to simply 'paint' them away. In this case, I have added a new transparent layer above the original image and cloned the lamps and curtains from the background onto the new layer. To do this, you need to enable the 'Use all layers' option for the clone tool (see page 33).

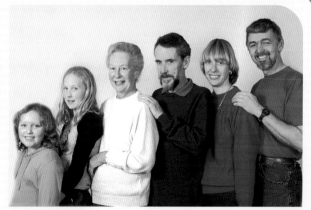

The end result

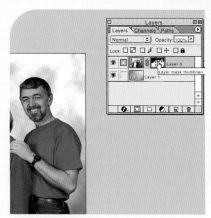

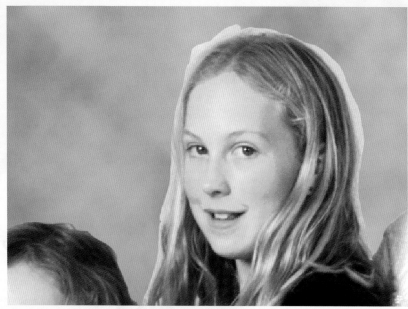

08 You can now fine tune the selection using the paint tools on the layer mask. Use black paint to hide pixels and white paint to show pixels. Remember, you can use soft brushes to give a 'feathered' edge to the mask in awkward areas.

09 Take special care with hair regions (see pages 56-57 for tips on this). The advantage of working on a Layer Mask is that you can keep editing it until you have the cut out exactly right, and at no time are pixels actually deleted. You can view the mask itself at any time (in Photoshop) by pressing the \ key (press it again to hide the mask).

Photoshop keyboard shortcuts
View layer mask \
Magic Wand W
Sample color Alt-click/option-click
Change brush size [(smaller)] (larger)

tools
Layer Masks
Paintbrush
Add Noise

keep in mind
Keep your new background similar in tone and texture to the original and the join will be much easier to disguise.

output 🖨️

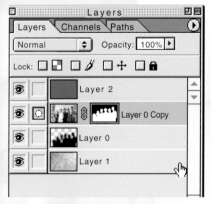

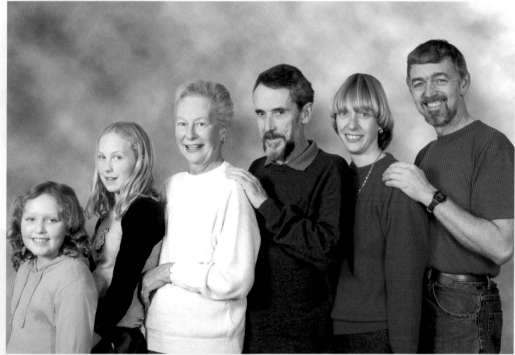

10 The end result has four layers: two created in steps 1-8, a grain layer (see page 107) to disguise the different textures of the original scan and the new background, and a faint shadow layer. This was created by duplicating the layer containing the people, discarding the mask and choosing image>adjust> threshold (to make the silhouette) and Filter>Blur>Gaussian Blur. The opacity was reduced to about 30%.

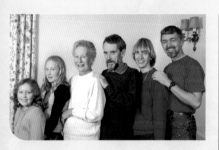

Quick Cheat
The background in party shots such as this can be quickly painted over with black to isolate the subjects. Use a feathered (soft) brush to blend the black into the hair or you will end up with an all too visible join.

🔍 **navigator**

Masking hair p56
Grain and texture p104
Adding emphasis p70

Masking hair

Probably the greatest challenge facing the digital portraitist is how to deal with hair. There are, however, ways around this problem, and you'll soon discover it never need be a bad hair day.

process

input

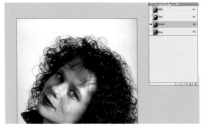

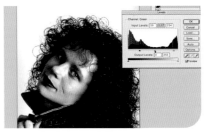

01 The problem with hair is that the individual strands are too fine to be picked up by conventional 'automatic' selection tools and the overall outline is invariably too complex to mask using paint tools, unless you have plenty of time on your hands. So what can you do if you want to place a new background behind someone without losing the fine detail of their hair? For one thing, it is a lot easier if the original background is a solid color and contrasts well with the hair itself, as in our studio shot above.

02 Our first technique needs an application that allows you to edit the separate red, green and blue channels independently, such as Photoshop. It also needs a plain background to start with. View each channel on its own. The easiest way to do this, is to open the Channels palette (under the view menu in Photoshop), which has the same hide/view icons as the Layers palette. Choose the channel that shows the most contrast between hair and background: in this case, it is the green.

03 Make a duplicate of the chosen channel (as with layers, simply drag the channel to the 'add a new channel' icon at the bottom of the palette). Rename this layer 'Mask'.

Adjust the Levels of the duplicate channel until you get the maximum contrast without losing too much of the fine detail in the hair. This is much, much easier if you started with a fairly pale background in the first place - something you should bear in mind when shooting.

technical details
6x4.5cm
single lens reflex
45mm lens
Fujichrome Velvia

 tools
Layer Masks
Paintbrush
Add Noise

 keep in mind
If shooting a portrait that you want to cut out, make life easy for yourself by using a brightly-lit white background in the first place.

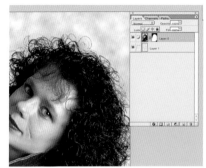

04 Still working on the duplicate channel created in step 3, use black paint to 'fill in' any areas of the person that are not currently black.

06 Once you are finished hide the new channel and show all the others. From the Select menu choose Load Selection.

08 Here, I have turned the selection from step 7 into a Layer mask and placed the image onto a new background as a separate layer.

 output

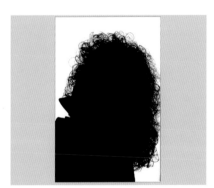

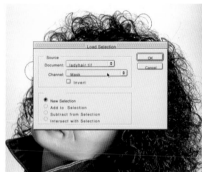

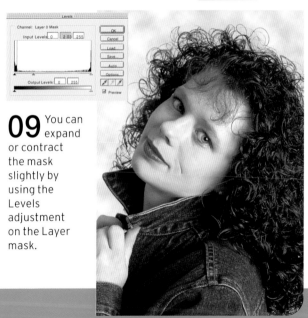

05 You are aiming to produce a perfect silhouette. It takes some practice and will require much more work if you also need to paint any of the background area white.

07 In the dialog box that appears, choose 'Mask' from the Channel drop-down list. Click on OK and you will see a selection appear around the model.

09 You can expand or contract the mask slightly by using the Levels adjustment on the Layer mask.

navigator

Photoshop Extract Tool

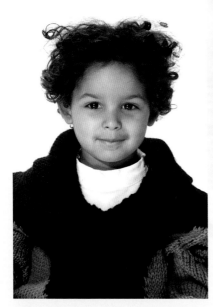

01 Later versions of Photoshop (complete, not LE) offer a remarkably useful new tool – the Extract function (found under the image menu). Extract is designed to do exactly what its name implies – to extract a subject from its surroundings. Although the process is relatively automatic, the interface for the feature does take a little practice to master.

02 Open your image and choose Image>Extract. The first step is to define the boundary – the edge – of what you want to extract. Use the edge highlighter tool (shown inset above) and draw roughly around your subject. For very fine hair detail or when the background is more complex, you should use a smaller brush and be prepared to take a little more time.

03 Once the edge is complete fill the areas you want to keep with the fill tool. This works just like the paintbucket (flodd fill) tool - just click once and it will fill the entire area inside the boundary created in step 2.

04 Click on the preview button. You will see the result of the extraction with the usual grey checkerboard indicating where pixels will be removed. If all is well, click on OK. If not, there are tools designed to edit the edge, but it is usually better to start again with a finer edge highlighter.

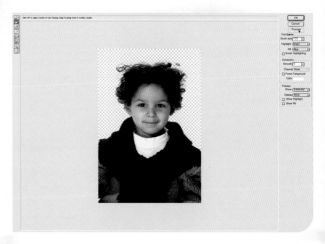

technical details
Nikon F100
Nikkor35-135
f3.5-4.5 AF-DIF
Minolta ScanMulti II
Adobe Photoshop 7.0

tools
Extract
Gradient Tool
Add Noise

keep in mind
Keep your new background similar in tone and texture to the original and the join will be much easier to disguise.

05 You can now drop in or, as here, create a new background for your subject as a new layer placed below the one containing your photograph.

06 Be sure to zoom in to at least 200% to ensure there are no stray pixels from the original background. If there are (as above), use the eraser and a small brush to remove them.

07 The end result is pretty convincing considering it took no more than ten minutes' work. As with all montages, you need to ensure that any new background works well with the tonality and texture of the original shot. This usually means adding some noise to the background layer (before you flatten the image) to match the grain in the original if it was scanned.

More Hair Masking tips

Use a soft edged brush to quickly mask hair with less distinct strands...

...with a little care you can produce a convincing result.

Use a textured brush (or create your own if possible) to paint away the edges of short hair.

Brush Name

Name: hairbrush

OK

Cancel

87

navigator

Grain and texture	p104
Black and white	p78
Toning	p86

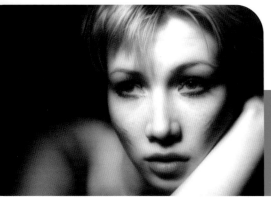

Softening and blurring

In portraiture, sharper doesn't always mean better, and photographers have always used a variety of filters to add a flattering softness to pictures of people. But softness and blurring are not the same thing.

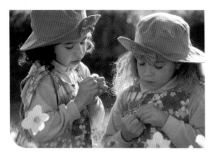

Input

01 We'll start with a nice summery shot snapped with a 35mm SLR and a short telephoto lens. Softening filters in conventional photography use patterns of tiny microlenses or etched lines to diffuse bright highlights across the image, rather than simply blurring or defocussing the entire picture. The result is that the image is still sharp, but the diffused highlights add an attractive softness.

process

02 The first step is to duplicate the image in a new layer (in Photoshop simply drag the layer thumbnail to the 'New layer' icon at the bottom of the Layers palette).

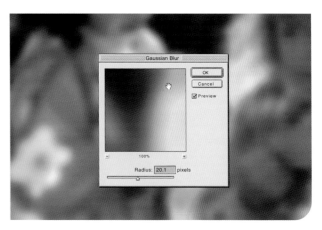

03 Next we need to blur the upper (duplicate) layer. Use the Gaussian Blur filter (filter>blur> gaussian blur) as this not only gives the most appealing result, it is the only form of blurring that has a dialog box to control the level of the effect. Use a large (say 20 pixel) radius setting.

technical details
Nikon F90X
Nikkor 28-105/
f3.5-4.5 AF-DIF
Minolta ScanMulti II
Fuji Provia 100
Adobe Photoshop 7.0

60 Step-by-step Projects

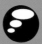

tools
Gaussian Blur
Duplicate layer
Blending modes

keep in mind
Although softening an image can disguise slight focus problems, the techniques described here really need a good sharp image to start with.

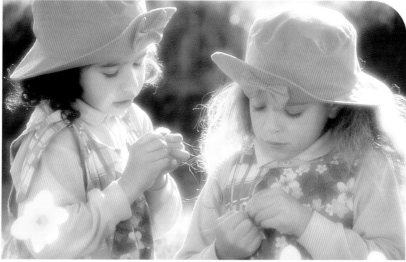

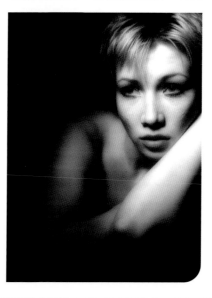

05 The end result: you may need to tweak the Levels to counter any excessive lightening caused by the previous step.

04 Change the blending mode of the new blurred layer to Screen. This produces the soft, diffused effect we are after, with the highlights 'bleeding' into the shadow areas.

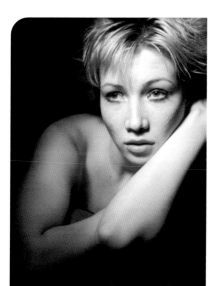

Multiplying mood
For a darker, moodier feeling change the blending mode of the upper, blurred layer to 'Multiply'. This gives an effect similar to using a diffuser on the enlarger lens when printing from negatives. Here the shadows/ dark areas bleed into the highlights (bright areas). This effect is obviously better suited to this 'film noir' style portrait than the two little girls on the previous page.

Further experimentation

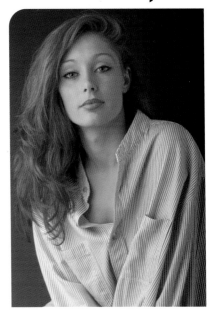

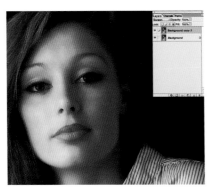

01 The technique described on the previous pages is about as near as you'll get to conventional photographic 'softening'. It is, however, always worth experimenting with variations on the technique. The beauty of the digital darkroom is that you can keep trying different filters and settings on the same image until you find exactly what best suits the image you are working on. We'll start with this fairly mundane home studio shot. It is well posed and well lit, but lacks any real impact.

02 Again we'll start by duplicating the image in a new layer.

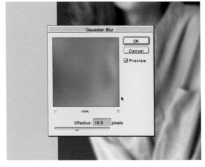

03 I'm not using quite such a strong blurring this time - around 10 pixels. The Radius figure you use will depend on the resolution of your original image. Lower resolution pictures need a lower radius setting for the same result.

04 Here I've changed the blending mode of the blurred layer to 'Darken'. The result is similar to Multiply but the image is much darker; you'll need to fix it using the Levels controls.

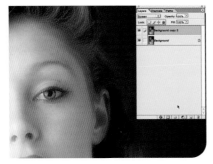

05 Screen mode is a little too subtle for the effect I am looking for; it tends to get lost somewhat in images that are low key.

tools
Gaussian Blur
Diffuse Glow
Blending modes

keep in mind
Keep your new background similar in tone and texture to the original and the join will be much easier to disguise.

06 Having played around with blend modes and layer opacities, I eventually ended up going back to Multiply mode, with the layer opacity set to 100%. The result is too dark so I added a Levels adjustment layer.

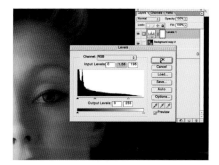

07 Adjusting the white point and mid-tone sliders brightens up the picture considerably without losing the subdued diffusion produced by the Multiply mode.

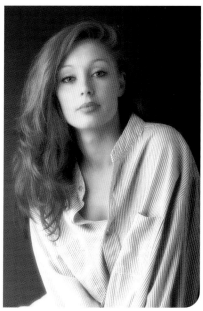

08 The final result: multiplying the original and blurred layers has intensified the color of the image and increased contrast. The softening is much more subtle than if we had used screen mode for the blurred layer.

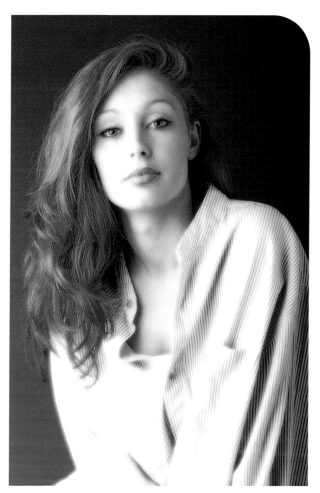

▲ Diffuse Glow
Photoshop features an interesting filter, Diffuse Glow, which produces an unusual kind of softening that works well on portraits, especially full face shots.

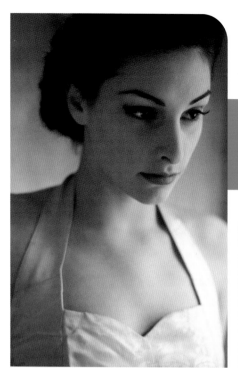

Selective blurring

Softening an entire image can be very effective, but the effect can often be made much more dramatic if it is restricted to certain areas of the frame – specifically those outside the face itself.

 process

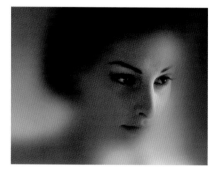

 Input

01 The pose, composition and lighting in this image are all pretty much spot on. This is a perfect illustration of how an attractive model, careful composition and a single diffused light source can produce a lovely image. The only flaw is that there is no part of the image that is particularly sharp. By softening the edges of the image whilst leaving the face untouched we should be able to add some impact.

02 Although you can simply select an area then blur it, it is always preferable to use a duplicate layer. Doing so allows us to preserve the information in the original image should you need to retrace your steps.

Create a duplicate of the background layer containing the image and run the Gaussian blur filter on the new (upper) layer. Use a high radius value (here I'm using 69 pixels).

03 You can now either use the eraser tool to remove areas of the upper (blurred) layer where you want the image to be sharp, or add a layer mask to the upper layer. The latter is preferable as it can be edited even after the file has been saved. If you are using the eraser method, change the opacity of the eraser (to say 50%) in the areas around the face to get a gradual blurring effect.

▲ Adding a layer mask

technical details
6x4.5cm
single lens reflex
45mm lens
Fujichrome Velvia
Adobe Photoshop 7.0

tools
Duplicate Layer
Eraser tool
Layer Masks
Gaussian Blur

keep in mind
The idea behind blurring only part of an image, is to draw attention to the most important part of the photograph. Always make sure that the eyes are the sharpest part of the frame.

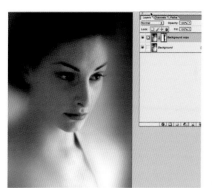 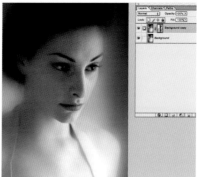

04 If you are working with a layer mask, you can try different paint opacities as you paint onto the mask itself. Black paint totally hides the blurring and greys result in some, but less blur.

05 Try to keep the completely sharp area fairly narrow, and gradually reduce the opacity of the mask as you work away from the face.

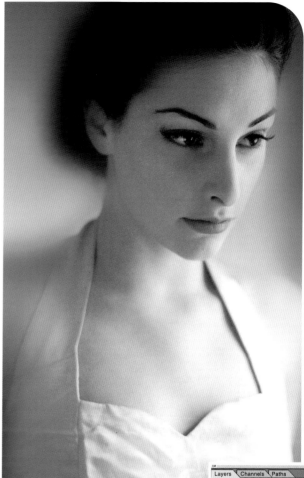

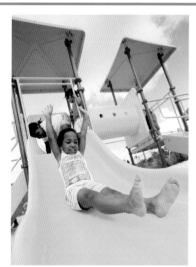 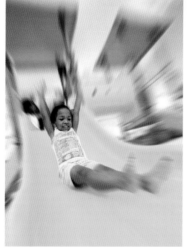

06 The screen on the right shows the Layers palette for this image, showing the finished layer mask.

Other types of blur Some subjects demand a different approach: here the duplicate layer has had a zoom blur (filter>blur>radial blur) applied to imply motion. See page 70 for similar ideas designed to draw attention to the subject of a photograph.

Depth of field

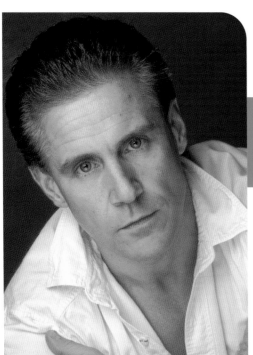

A more refined version of selective blurring is depth of field. Traditionally portraits are shot with a very limited depth of field, something we can recreate digitally...

process

input

01 Portraits are usually taken with a long lens and wide aperture in order to minimise the depth of field (the degree of sharpness in front of and behind the point of focus). Unfortunately, you cannot always get the narrow depth of field you require, especially if using a compact camera that lacks a long lens or aperture control. Studio flash shots such as this one can also cause problems simply because the flash is too bright to allow the use of the very wide apertures.

02 The process is very similar to that described on the previous page: the first step is, again, to duplicate the background layer.

03 Run the Gaussian Blur filter on the new (upper) layer. Use a lower radius value this time; I've used a radius of around 30 pixels (the actual amount needed depends on the size of the image).

No layer masks? If your application doesn't support layer masks you can use Quick Mask mode (sometimes called 'paint on mask') to create a circular gradient selection on the upper (blurred) layer, which you then invert and delete. Alternatively simply make a circular selection on the upper layer and feather before inverting and deleting.

technical details
Mamiya 645N single lens reflex
110mm lens
Fujichrome Velvia

 tools
Taking the shot
Scanning

 keep in mind
This simple technique only works on straight on portraits. If the head is turned or is a profile, you'll need to use the method described over the page.

04 Add a layer mask to the upper (blurred layer). If your application does not support layer masks, see the box at the bottom of the opposite page.

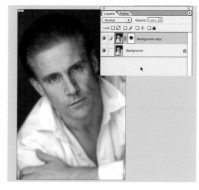

06 The result is an image that is sharp in the centre and gradually more blurred towards the edges.

05 Use the gradient tool (shown inset) to create a circular gradient from black to white on the layer mask. It helps to make the mask visible at this stage (press \ in Photoshop).

07 To add further emphasis, increase the brightness of the original (sharp) layer very slightly, or darken the new (blurred) layer.

08 The end result. Make sure you print at 100% to see the full effect of the blurring.

navigator
Selective blurring p64
Levels p36
More depth of field p68

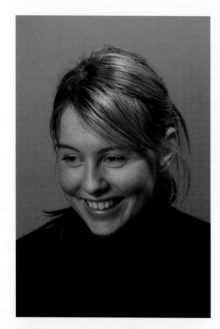

01 Although the method described on the previous page works remarkably well for recreating narrow depth of field, it doesn't take into account how far from the lens each part of the image is. Since the more blurred areas should be those furthest from the point of focus (which should be the eyes), we need to be a little more careful when masking for a truly realistic effect. This is especially true of images such as this one, where the subject is not photographed face on.

02 The first step is to correct any color, brightness and contrast problems with the photograph. Next, as before, create a duplicate layer and apply a Gaussian blur.

Use the lasso to draw a freehand selection around the areas you want to be sharp – in this case I've selected the entire centre of the face. Don't worry too much at this stage about drawing an accurate outline as this is simply our starting point. Feather the selection by around 35 points (for an image 2000 pixels wide).

03 Add a layer mask: it will be based on the selection you have made.

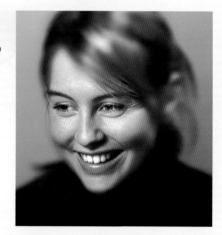

04 You will immediately see the result of the mask: it will hide the blurred layer inside the area you selected in step 2.

technical details
Fujifilm FinePix S1 Pro Digital SLR
28-80mm lens (at 80mm)
Adode Photoshop 6.0

tools
Levels
Gaussian Blur
Dupicate Layer
Layer Mask

keep in mind
This entire process can be done without using Layer masks (if you have an LE version of Photoshop) by working in Quick mask mode to make a selection and deleting part of the upper (blurred) layer.

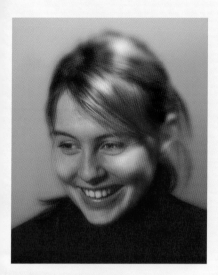

05 You now need to paint the mask using various Opacities of black paint. First make the mask visible by pressing the \ (back slash) key. Use 100% (black) in areas you want sharp and leave areas furthest from the point of focus white (these will have the strongest level of blurring). As areas of the image get further away from the point of focus, use progressively lighter shades of grey (lower opacities of paint). The screenshot above shows the process around half way through. The eyes, nose and mouth have been left sharp, and the mask gets gradually lighter towards the back of the model's head.

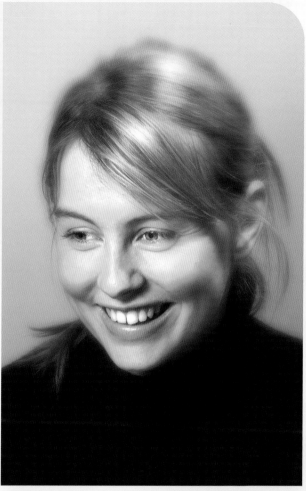

06 The end result is pretty convincing. The only problem is that Gaussian blurring only gives a similar (not identical) effect to being 'out of focus'.

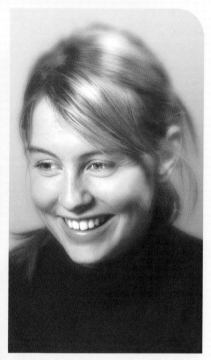

07 I find that recreating narrow depth of field in this manner often looks more convincing on monochrome images – although I'm not really sure why!

Judge for yourself by converting to greyscale (or, as here, duotone) mode. Remember that converting color modes usually flattens the image (merging the layers), so make sure you save the image as a new file if you like the results.

Emphasizing the subject

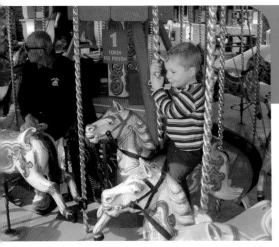

Many of the projects in this book are designed to draw attention to the main subject of the photograph. Here are a few more ideas for adding emphasis to your models.

process

Input

01 Many snapshots of friends and family suffer from clutter, too many distractions in the frame fighting for attention and reducing the emphasis on the actual subject.

This digital camera shot is typical – the even illumination and overall sharpness actually detract from the composition. We want the eye to jump immediately to the real subject of the shot: the little boy in the centre of the frame.

02 There are several ways of emphasizing the main subject of a picture, some of which we'll cover over the next few pages. In this case, we'll use a variation on selective blurring. As before, start by duplicating the layer containing the image itself and running a Gaussian blur on the new (upper) layer; filter>blur> Gaussian Blur.

03 Add a layer mask to the upper (blurred) layer by clicking on the 'Add a mask' icon at the bottom of the Layers palette. As with all these projects, I am using Adobe Photoshop, but other applications offer similar features. Using a foreground color of black and the paintbrush tool, paint onto the mask over the main subject – in this case the boy.

technical details
Sony Cyber-shot P5
Digital Camera
Adobe Photoshop 6.0

tools
Layer Masking
Gaussian Blur
Motion Blur
Curves

keep in mind
As with all image enhancements, less is often more: for a subtle but effective result, don't overdo the blurring or darkening of the upper layer.

04 I've extended the sharp area (the area covered by the mask), to cover the upright poles immediately in front of and behind the boy himself. Use a soft brush for areas where you want the sharpness to fall off gradually.

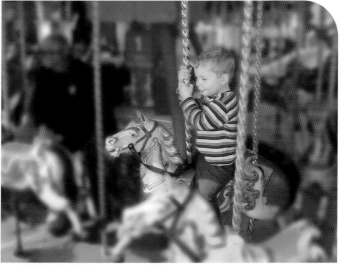

06 The end result, ready for printing. Again, using a layer mask (rather than simply deleting areas of the blurred layer) means we can always go back and change the areas we want to be sharp.

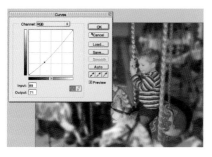

05 Make the upper (blurred) layer a little darker than the sharp area using the Levels or (as here) Curves controls. This adds further emphasis.

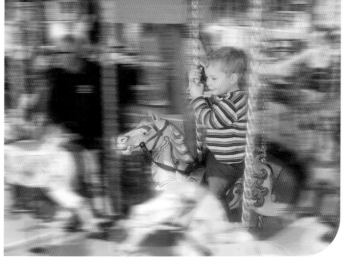

07 A variation of this technique that works really well in a case such as this, is to use Motion Blur (filter>Blur>Motion Blur) instead of Gaussian Blur at step 2. Set the direction of the motion parallel to the motion in the scene itself.

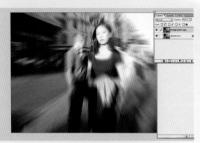

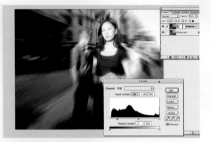

02 Start, as before, with a duplicate layer. Apply a radial zoom blur (Filter>Blur>Radial Blur). Try to set the center of the blur somewhere in the region of the main subject's face.

04 Still working on the upper (blurred) layer, not the mask, use the Levels controls to darken the mid-tones (move the middle slider to the right). I also moved the black point slider a little to the right.

01 Another variation on the procedure detailed in the previous pages is to add a zoom blur, as opposed to a motion or Gaussian blur, to the image.

This candid digital camera shot was grabbed on Oxford Street in central London and suffers from a confusing central area due to the presence of other, sharply focused people just behind the main subject.

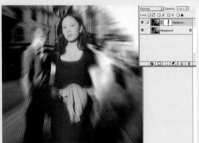

03 Add a layer mask to the upper layer and paint over the area you want to hide (that is, the area you do not want to be affected by the blurring). In this case, you want a soft edge to the mask, so use a large soft brush.

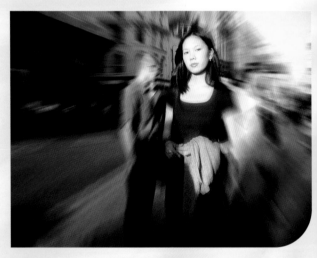

05 The final touch was to alter the color balance of the blurred layer to make it bluer than the original.

Photoshop keyboard shortcuts
View layer mask \
Lasso L
Make new layer shift-ctrl-N/shift-⌘-N
Levels ctrl-L/⌘-L

tools
Layer Masks
Radial Blur
Levels
Paint tools

keep in mind
Change the blend mode of the upper (blurred) layer to get radically different effects.

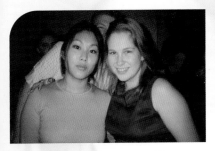

Starting with a shot nicely lit from a side window, we can easily create a studio-like portrait. Combining some selective blurring (to recreate narrow depth of field), levels alterations, a little dodging and burning and painting around the subject with black, the original is completely transformed.

01 Sometimes the simplest techniques are all it takes to make the subject of a portrait jump out of the frame. This party shot has a distracting extra person in the immediate background.

02 After sorting out the levels of the image, draw a rough selection around the subjects. Feather the selection and create a new layer (without deselecting). Now simply fill the selection (on the new layer) with black paint.

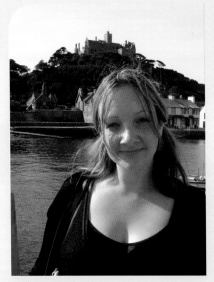

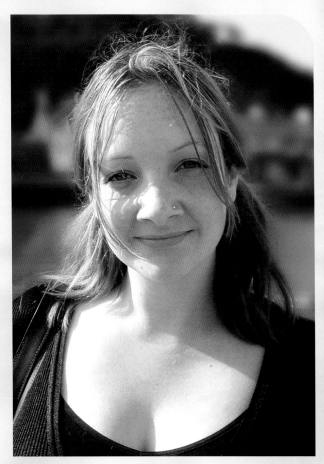

01 Many of the techniques described in this book can be combined to add emphasis to the subject of a portrait. This snap - taken with a basic compact digital camera - has several problems. First, the automatic exposure has left the face a little dark compared to the background. The fixed wideangle lens and bright light (giving a small aperture) have also resulted in a large depth of field, so even the buildings on the far side of the harbour are in sharp focus. The first step was to fix the overall brightness and crop the image slightly.

02 The screenshot above shows the Layers palette for the final image (shown on the right). At the bottom is the original file. Above that, is a blurred copy with a layer mask hiding the subject herself. A soft edge has been used on the mask around the hair to make life easier and to give the impression of very narrow depth of field.

Next up is a Levels adjustment layer to darken the background using a mask that is the inverse of that used on the blurred layer.

Finally, the top layer is a Hue and Saturation adjustment layer set to increase the color saturation of the image except in the skin area, which would otherwise look over-saturated and far too pink.

03 The end result is a marked improvement on the original, and successfully pulls the subject out of the scene. The blurred and over-saturated background may not be very natural, but the overall effect is to turn an uninspiring snapshot into an attractive portrait.

Photoshop keyboard shortcuts
View layer mask \
Magic Wand W
Sample color Alt-click/option-click
Change brush size [(smaller)] (larger)

tools
Adjustment layers
Hue/saturation
Levels
Gaussian Blur

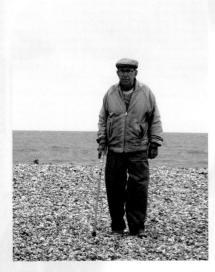

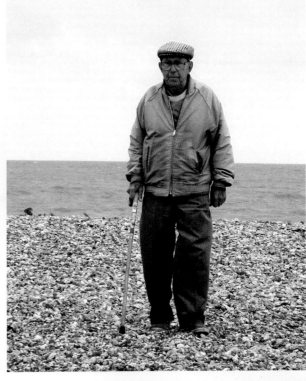

01 In the last example, I increased the saturation of the background to add emphasis to the main subject. Here, I'm going to reduce the saturation.

02 For this project, I'm going to use Photoshop's Quick mask mode to make my selection. To enter Quick mask mode, click on the icon (shown above) at the bottom of the toolbar.

03 Make your initial selection using whichever tools suit the purpose – I used Photoshop's magnetic lasso. Turn the selection into a Quick mask (press Q) and clean up the edges using a small paintbrush and a foreground color of black. Turn the quick mask back into a selection (press Q again) and create a new Hue/Saturation adjustment layer (Layer>New Adjustment Layer>Hue/Saturation). When the Hue/Saturation window appears reduce the saturation slider to zero and press Ok. A mask based on your selection will automatically be added to the adjustment layer (as below).

04 The end result is subtle, but effective. You can use a similar method to add color toning to selected areas of a scene: simply click on the 'Colorize' option in the Hue/Saturation dialog. Because the alterations have been applied using an adjustment layer you can go back at any time and change the masking and the effect applied.

Photoshop keyboard shortcuts
Quick Mask mode Q
Magic Wand W
Invert Selection shift-ctrl-i/shift-⌘-i
Change brush size [(smaller)] (larger)

navigator
Selective monochrome p88
Toning p86
Fixing colors p42

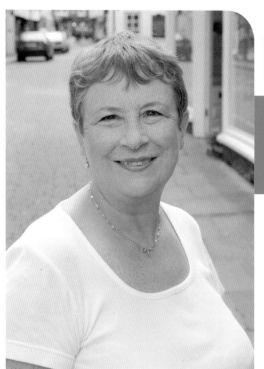

High-key portrait

By taking the ideas of the past few pages a little further and removing all extraneous detail entirely, it is possible to turn an everyday snap into a professional-looking studio shot.

process

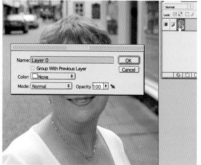

input

01 The prime requisite for this project is a suitable shot to start with. This snap was taken on a digital SLR on a bright, but slightly overcast summer's day. The diffused lighting is very flattering and both exposure and focus are spot on. I also used a short telephoto lens – perfect for this kind of head and shoulders shot, minimising as it does any unflattering distortion.

02 The first step is to turn the background layer (which is by default locked) into a 'normal' layer that can be masked. Double click on the layer thumbnail on the Layers palette and click OK when the New Layer window appears.

03 Add a new layer underneath the one containing your original image and working on the upper layer (the one with the image), draw a rough outline around the person. I'm using Photoshop's Magnetic Lasso here - this tool will automatically 'snap' to any edge as you draw. If necessary, clean up the resulting selection using Quick Mask mode (press Q and edit the mask directly using the painting tools).

technical details
Fujifilm FinePix S1 Pro
Digital SLR
28-80mm lens
76 Step-by-Step Projects | Adobe Photoshop 6.0

 tools
Magnetic Lasso
Quick Mask
Layer Masks
Gaussian Blur

 keep in mind
The success of this kind of project depends on the quality of the original, most specifically, the illumination. If shooting to recreate a studio portrait, aim for diffused, even lighting.

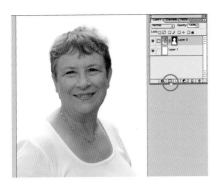

04 To add a layer mask, with the selection still active, click on the 'Add a Mask' icon (circled here in red) at the bottom of the Layers palette. Then clean up the mask.

06 To simulate narrow depth of field, enter quick mask mode (working on the upper layer) and use the circular gradient tool as shown above. You want a gradient that starts white in the centre and fades to black at the edge of the frame.

Turn the quick mask back into a selection and run the Gaussian blur filter. The blurring will have no effect in the centre of the frame, getting gradually stronger towards the edges.

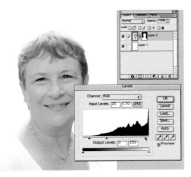

05 Adjust the levels on the top layer (the one containing the person) to lighten the mid-tones. You may also want to move the white point slider slightly to the left to lift the highlights.

07 A few minutes spent cleaning up any blemishes, lightening the eyes and tweaking the levels, and you have a picture that no one would imagine was actually snapped in the street.

navigator
Depth of field p66
Removing blemishes p46
Fixing colors p42

Photoshop keyboard shortcuts
View layer mask \
Quick Mask mode Q (to enter and exit)
New Layer ctrl-shift-N/⌘-shift-N
Feather selection ctrl-alt-D/⌘-option-D

Black & White

The past few years has seen revival in the popularity of monochrome portraiture, and the great news is you no longer need a darkroom!

01 The beauty of digital photography is that taking the shot is no longer the final step in the process. Image editing software is - in the right hands - so powerful that you can recreate virtually any conventional photographic technique from a basic color original. Where once you had to commit to shooting in black and white when you loaded the film, you can now experiment with the infinite flexibility of monochrome despite shooting in color 100% of the time.

02 At its simplest, turning an image b & w consists of changing the color mode to greyscale (image> mode > greyscale).

03 An alternative is to desaturate the image (image>adjust> desaturate). This gives a marginally flatter result, but the mode stays RGB.

technical details
Fujifilm S1 Pro
Digital SLR
28-80mm lens
Adobe Photoshop

tools
Greyscale mode
Desaturate
Channel Mixer

keep in mind
When printing black and white images on a color photo printer, it is very difficult to get a totally neutral grey tone. Printing with the black ink removes this problem, but the results won't have such a smooth range of tones.

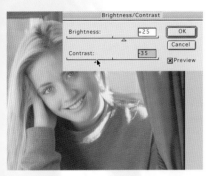

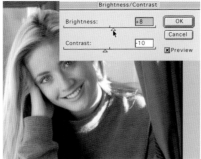

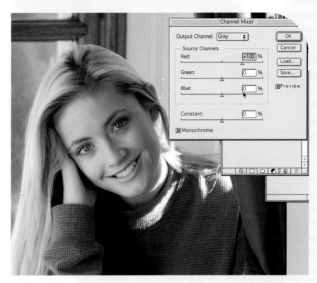

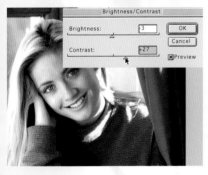

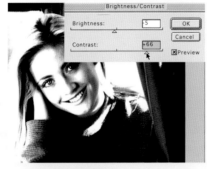

04 As with the conventional darkroom, digital b & w offers almost limitless variations. Try experimenting with different Brightness and Contrast Levels or Curves settings. If you've ever worked in the darkroom, you will soon discover you can recreate any type and grade of paper and any level of exposure.

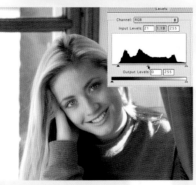

05 Conventional b & w photography is often enhanced with the use of colored filters. These mean the film is only exposed to certain colors, dramatically altering the tonal quality of the image.

In Photoshop, we can recreate the effect of color filters using the Channel mixer (image>adjust>channel mixer). Open the channel mixer on a color image and check the Monochrome option. The settings shown above are the default settings and give a result similar to simply converting to greyscale. Note that the red channel provides most of the information.

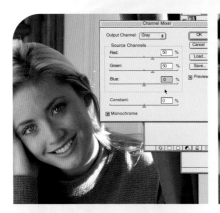

06 By reducing the amount of red and increasing the green, the skin tones are darkened.

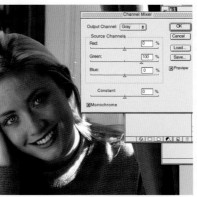

07 Increasing the green to 100% and reducing the red to 0, results in much darker skin tones. The three channels should always add up to 100% for the overall exposure to stay the same.

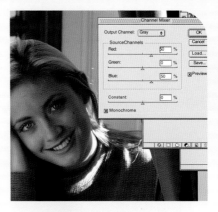

08 Reducing the red and adding 50% blue darkens the skin, although less than at step 6.

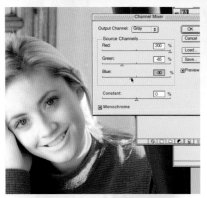

09 Taking the red to 200% and reducing the green and blue to less than zero, produces a result similar to using an infrared film.

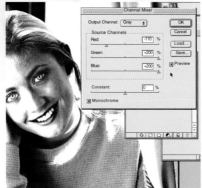

10 Experimenting with extreme settings produces interesting, if somewhat drastic results.

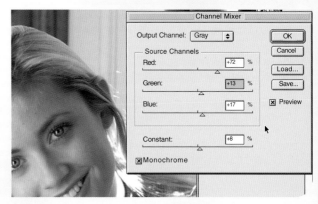

11 My choice for this image: changing the Constant slider (bottom of the window) alters the overall brightness.

Photoshop keyboard shortcuts

Desaturate	shift-ctrl-U/shift-⌘-U
Levels	ctrl-L/⌘-L
Reset in dialog box	Alt/option
Dodge/burn tool	O

tools
Channel mixer
Dodge & burn
Brightness & contrast

keep in mind
Removing the color from an image makes many complex procedures – such as montage – much easier to get right.

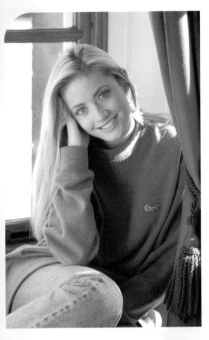

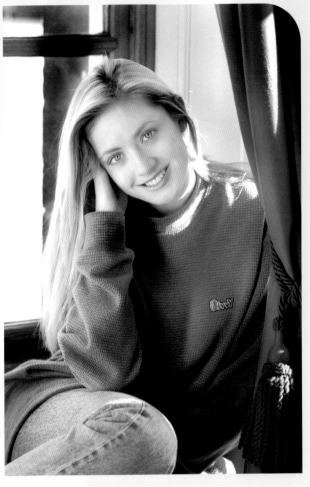

12 The result of the Channel mixer settings shown in step 11.

13 The same image after a little dodging and burning (see below).

Painting with light: dodging and burning

Conventional darkroom experts use various physical methods to alter the amount of exposure given to different areas of a b & w print. By dodging (reducing exposure) and burning (increasing exposure), it is possible to selectively lighten and darken parts of the image to get the perfect result. It is a difficult process, and very hard to master. Fortunately, the digital darkroom makes the whole process much easier.

14 The finished result after channel mixing, dodging and burning and adjusting the brightness and contrast.

Original image

Face lightened with burn tool

Eyes and mouth darkened with dodge tool

The dodge and burn tools can be used with any paint brush and options let you alter the strength of the effect and whether it works on highlights, shadows or mid-tones.

Fine-tuned b&w

Having covered some of the basics of digital monochrome over the last few pages, it's now time to fine tune the process to produce the best possible b & w prints from color scans.

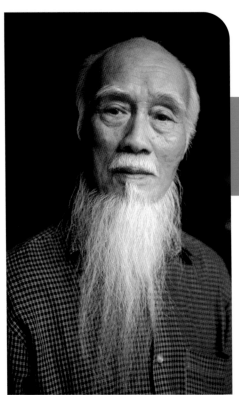

 process

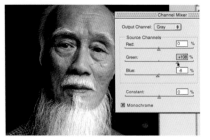

input

01 Some images only work in color, and some are transformed when converted to b & w. Others, such as in this example, are equally effective whether color or monochrome. What we can do in mono which is difficult to pull off effectively in color, is to up the contrast slightly to emphasize the character in the lines of the subject's face.

02 The first step is to remove the color. I've opted to use Photoshop's Channel Mixer, reducing the red content to 0% and upping the green to 108%. To ensure the overall exposure didn't change, I reduced the blue content by 8% (to give a net total of +100%).

These figures were not reached by deduction, but by experimenting with the settings for a few minutes. I specifically wanted to keep detail in the beard, even though the face is left too dark.

03 Although the Channel Mixer has produced the result I wanted in the beard, the process has left the face a little dark. To put this right, I need to adjust the levels of the image in the face area only. The most controllable way to do this is via a Levels Adjustment Layer – an editable levels control with its own mask that allows us to protect areas from the effect of the adjustment. Choose Layer>New Adjustment Layer>Levels. Click OK when the new layer window appears.

technical details
Nikon F801
Nikkor 28-105
Fuji Velvia
Adobe Photoshop 6.0

 tools
Taking the shot
Scanning

 keep in mind
Keep your new background similar in tone and texture to the original and the join will be much easier to disguise.

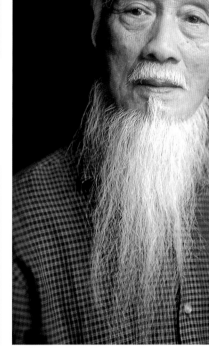

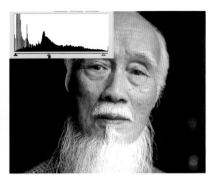

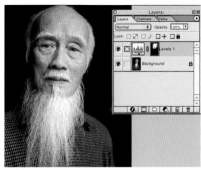

04 I can now adjust the levels to lighten the mid-tones (moving the middle slider to the left) until I am happy with the brightness of the face.

05 Painting on the Adjustment Layer mask, I returned the rest of the picture back to how it was in step 3.

06 I next flattened the image (which applies and removes the Levels adjustment layer) and used the techniques described on pages 70-75 to selectively blur the image in all areas except the face. Using a blurred duplicate layer, I was able to vary the opacity of the mask to give the impression of a very narrow depth of field. The final step was to sharpen the underlying (original) layer using the Unsharp Mask control.

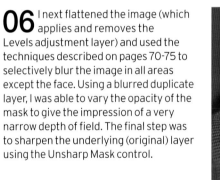

07 The end result was printed onto high gloss inkjet paper using all the color inks, resulting in a slightly cool tone, which didn't detract from the image.

Red Green Blue

One channel at a time...
Many applications allow you to view the red, green and blue (RGB) channels of an image individually, and to save each channel as a new greyscale image. This is often worth having a look at, especially if you do not have the channel mixer feature.

B&W makeovers

Many compact cameras produce unsatisfactory portraits when using their onboard flash, with harsh, unflattering lighting. Although we can't make a silk purse out of a sow's ear, it is possible to carry out some improvements.

process

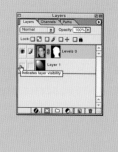

input

01 Modern compact cameras - be they digital (as here) or conventional - can produce remarkably sharp, vivid results, especially when you use the built-in flash. Unfortunately, for portraits the harsh bright light of the flash blasting your subject from a few feet away is a guarantee of an unflattering result.

Removing the background, converting to monochrome and adding a little texture can help disguise the problems, but don't expect miracles!

02 First, remove the color (I reduced the saturation to 0). Duplicate the layer and cut out the head using a layer mask. You can now see the new layer on its own; the background layer has been temporarily hidden.

03 Now delete the contents of the original (background layer) and create a new background. I've used Photoshop's Lighting Effects filter (Filter>Render>Lighting Effects) to produce this 'spotlit' background.

technical details
Nikon Coolpix 995
Digital Camera
Built-in flash
Adobe Photoshop 6.0

 tools
Hue/Saturation
Lighting Effects
Masks
Add Noise

 keep in mind
It is very difficult to change the harsh, flat effect of on camera flash. If you are taking a serious portrait, use bounce flash or - even better - a large diffused light source, such as sunlight through pale curtains.

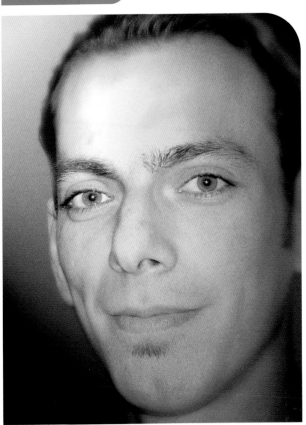
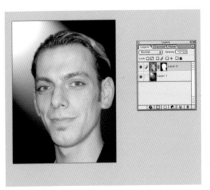

04 View both layers and edit the mask on the upper layer (using paint tools), until the edge is seamless.

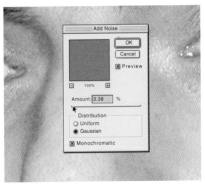

06 Add some noise to the final image. Ideally, you should use a separate layer to do this (see page 106 for details on how to create a texture layer).

07 Finally, I ran the lighting effects filter again, this time on the face layer to give the impression of some directional lighting. I reduced the contrast of the new background layer. The image was cropped and toned blue (see page 86).

05 If the image is too sharp, use the methods described on the previous pages to mask an area of the face and run the Gaussian blur to soften the rest of the subject.

Side lighting This technique can produce stunning results if the original photograph has more flattering lighting in the first place. This example is lit from the left using a window, and the end result is much more satisfying.

navigator

Toning B&W images

Adding color to a b & w portrait can have a remarkable effect, the subtlest of changes altering the whole mood. And even the most basic applications have all the tools you'll need...

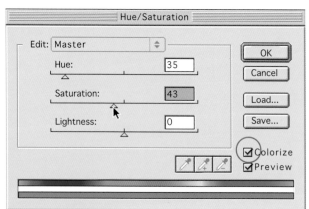

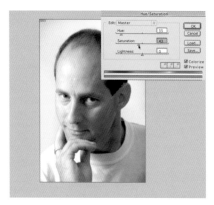

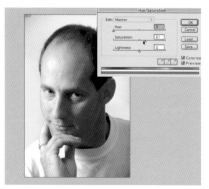

 input

01 To prepare my starting picture, I removed the background and used the channel mixer as described on pages 78-80 to get the black and white image I was after.

 process

02 The easiest way to add a tone to a b&w image is to colorize it using the Hue/Saturation controls. To do this, your image must be in RGB mode. Click on the 'Colorize' option and experiment with different Hue and Saturation settings. You can - in full versions of Photoshop - apply these changes as an Adjustment Layer.

technical details
Pentax MX + 85mm lens
Fujichrome Velvia
Nikon LS4000
Scanner

86 Step-by-Step Projects

tools
Hue & Saturation
Greyscale mode
Duotone mode

keep in mind
You can only perform Hue/Saturation changes on an image in RGB mode - even black and white pictures must be converted to RGB first. Conversely, you cannot go directly from RGB mode to Duotone - convert to greyscale first.

04 Photoshop offers an alternative method of toning: the Duotone Mode (image>Mode> Duotone). Choose a color for the second ink and click on OK.

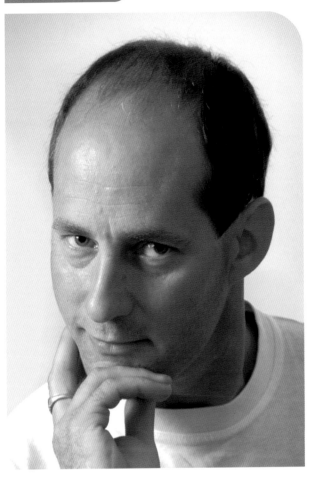

03 The Hue slider changes the overall color, the Saturation one the vividness of tone. The screen below shows the settings for our final choice.

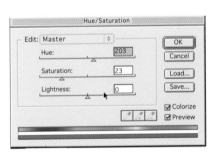

05 Click on the curve thumbnail to alter the Duotone curve, which defines the relationship between the two inks (black plus the color chosen in the previous step).

06 Whether you use Hue/Sat or Duotones to produce your toned images, the result will be pretty much the same. Use redder tones to warm up an image and bluer tones to cool it. Printing to a photo inkjet may slightly shift the tone.

navigator
Selective exposure p38
Curves p40
Fixing colors p42

Photoshop keyboard shortcuts
Hue & Saturation ctrl-U/⌘-U
Desaturate shift-ctrl-U/shift-⌘-U
Reset dialog box Alt/option

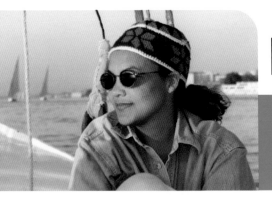

Mixed color & mono

Working digitally means nothing is impossible – think creatively and every shot can produce many different pictures. Here are a couple more ideas for using b & w and color together.

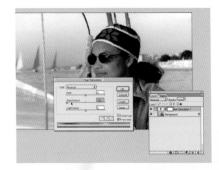

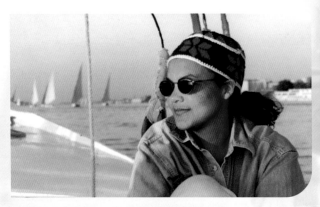

01 The color can be stripped from an image by reducing the saturation to zero. By selecting an area of the scene first, you can choose to leave part of the picture in color and make part of it b & w. This is a very effective way of emphasizing the main subject within the frame.

A more controllable method is to use an Adjustment Layer. Select Layer>New Adjustment Layer>Hue/ Saturation and reduce the saturation to zero.

02 Make the Adjustment Layer mask active (click on its thumbnail, shown above circled in red). Using the paintbrush and a foreground (paint) color of black, you can 'paint back' the color from the original scene.

03 The end result: the final Layers palette for this image is seen below, to show the final layer mask.

technical details
Mamiya 645 6x4.5cm
single lens reflex
75mm lens
Fujichrome Velvia

tools
Adjustment Layers
Hue/Saturation
Paint tools
Selection tools

keep in mind
For maximum impact, keep the area you leave in color quite small. For example, a tightly cropped black and white face shot with bright red lips can look very striking.

Hand colouring

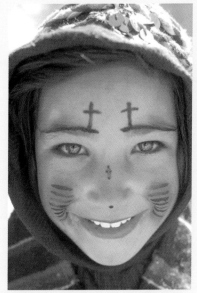

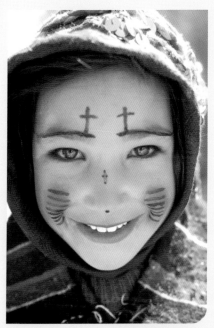

03 Change the blend mode of the new layer to Overlay and the opacity to around 55%. Start to paint onto the new layer; don't worry too much about accuracy and try to stick to a limited color palette.

04 This technique is a perfect way of pulling a subject out of a busy, distracting background.

01 A variation on this technique is hand coloring of monochrome images.

02 Change the color mode of the image to RGB and add a new layer above the background (the one containing your photo).

navigator
Selective exposure p38
Toning p86
Black and white p78

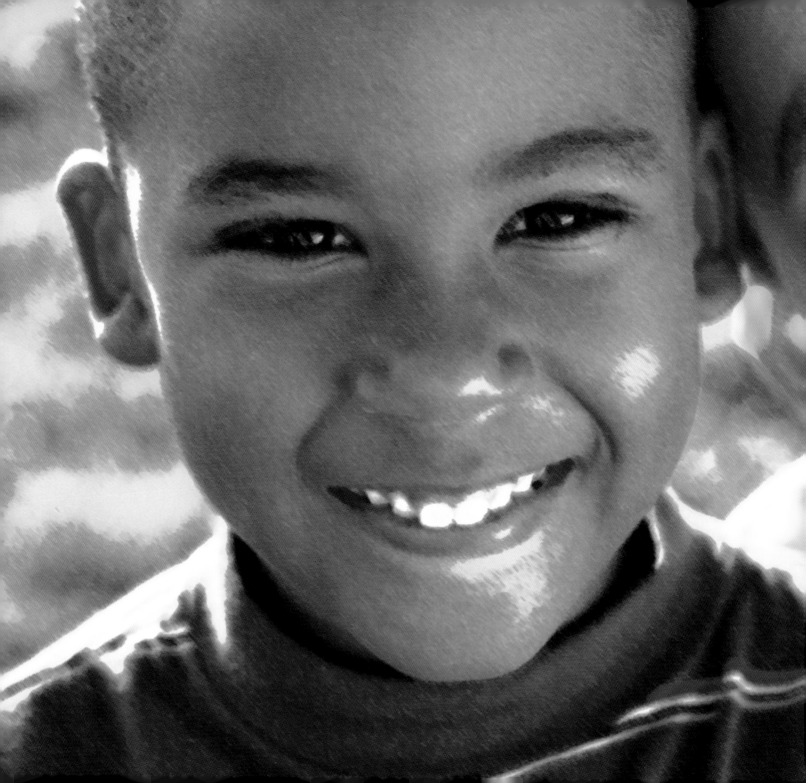

CHAPTER FOUR

SPECIAL EFFECTS

Creative borders

The 'icing on the cake' for some of your photographs will be provided by adding a border, and it is remarkable how much impact such a simple step can have. Here are some of the more popular techniques.

process ↖

Canvas Size

Current Size: 12.3M
Width: 14 cm
Height: 22 cm

OK
Cancel

New Size: 12.3M
Width: 14 cm
Height: 22 cm
Anchor:

Layer 1
Layer 2

input

01 Photographs such as this high key portrait don't need any extra work to make them better, but the preponderance of white does mean the edge of the frame is undefined. Adding a border can concentrate the viewers attention on the picture itself - the eye may otherwise wander off or around the page.

02 The simplest frame is a straight, solid border. The easiest way to add one is via the Canvas Size controls. First, set the background color to black (or whatever color you want for the border). Choose Image>Canvas Size and increase the dimensions by the amount you want for your border. Leave the anchor point in the middle.

03 A variation of this technique is to add another layer to your image underneath the photograph itself. After increasing the canvas size, fill the underlying layer with your color of choice. This allows you to adjust the position of the image within the border.

technical details
Canon T90
90mm lens
Kodachrome
Adobe Photoshop 5.5

tools
Canvas Size
Fill
Layer Masks
Paint tools

keep in mind
Try to use edges and borders that are sympathetic to your subject - very bold treatments will not work so well on a shot of granny!

04 Add a layer mask to the upper layer (the one with your photo) by drawing a rectangular selection around an inch or so in from the edge of the picture and click on the 'Add a Layer' icon.

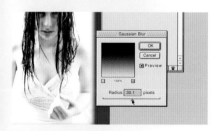

05 You can now manipulate the mask to alter the character of the edge of your picture. Here I am running a Gaussian Blur on the mask.

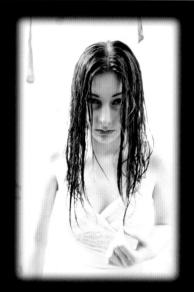

06 The end result: since the edge is defined by a mask, you can go back at any time and change it. The same technique can be used to produce more conventional oval vignettes (with a white background layer). If your application does not support layer masks, use a Quick mask or feathered selection and delete the edge pixels.

If you are working with a Layer mask or Quick Mask you can use any paint tools or effects filters on the mask itself to produce some pretty wild edges.

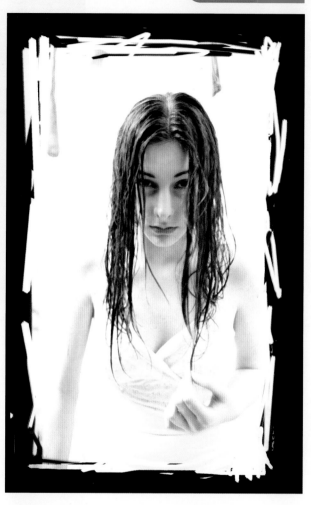

07 For a graphic, contemporary look, erase the edges of the mask with textured brushes.

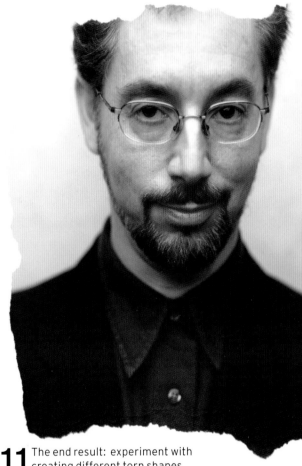

09 You want to end up with the result above: the paper in a separate layer above your photo. You may need to resize the new layer to cover your photo perfectly (use the Edit>Transform>Scale or Edit>Free Transform menus).

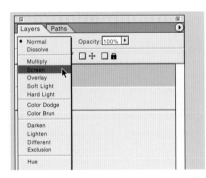

08 For an interesting modern look tear a sheet of paper into a shape roughly the same as your image. Scan the sheet using a flatbed scanner and adjust the levels so that the shape itself is black and the rest of the frame white. The quickest way to do this, is with the black point and white point eye droppers in the Levels window (Image>Adjust>Levels).

Drag the paper image onto your target photo or copy and paste it as a new layer.

10 Change the blend mode of the upper (paper) layer to Screen; you will immediately see the underlying photo in any part of the upper layer that is not white.

11 The end result: experiment with creating different torn shapes and using semitranslucent materials (such as sticking tape).

Photoshop keyboard shortcuts
Transform layer	ctrl-T/⌘-T
Copy	ctrl-C/⌘-C
Paste	ctrl-V/⌘-V
Levels	ctrl-L/⌘-L

tools
Scanning
Drag Layer
Selections
& Masks

keep in mind
Always print onto the best possible paper available, or all your hard work presenting your images will be wasted.

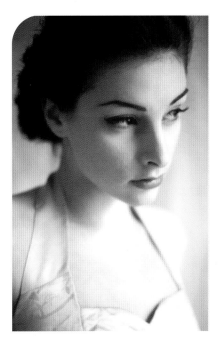

12 You can often create a border using nothing but the image itself, especially using images with strong details and little background clutter.

13 By creating a rectangular selection, inverting the selection and increasing the brightness, the face area is emphasised but left in context.

14 In this example, the image has been duplicated and placed on a larger, blurred version of itself. The larger version has also had a slight hue shift.

Presentation
The success of many prints lies in the careful presentation of the photography. By using a double border such as this one, the eye is forced to view the image in isolation. The white space around the picture gives it room to breathe and increases the perceived value of the image (much like an expanse of white wall in a gallery), whilst the solid black line stops the eye from wandering away from the picture itself.

navigator
Playing with color p98
Scanning p24
Adding emphasis p70

High contrast

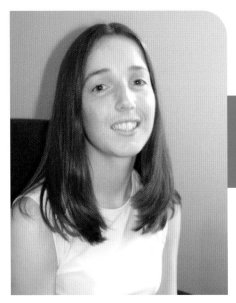

Even the most dire original can be transformed into a fashionable, graphic image with a little creative digital trickery. In fact, going to extremes is often the only way to salvage some shots.

process

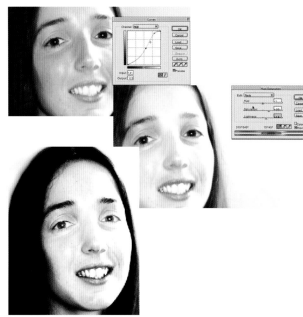

input

01 The picture I'm starting with has little going for it: as well as being slightly out of focus and slightly overexposed it has multiple light sources and an ugly office background. The first job is to reduce the saturation of the image .

02 Next to remove that ugly background. Using the techniques described on page 52, I've placed the image in a layer with a layer mask. With this kind of treatment you can mask the hair quite roughly using a soft edges brush.

03 Using the curves and levels controls, increase the contrast. I also used the dodge and burn tools to lighten the face and increase contrast.

technical details
Canon D30 Digital SLR
Tamron 90mm lens
Adobe Photoshop 6.0

tools
Hue/Saturation
Levels & Curves
Motion Blur
Layer masks &
Layer blending

keep in mind
The key to success in this kind of project is experimentation. You will find that your experimentation gets more successful as you master all the tools of your application!

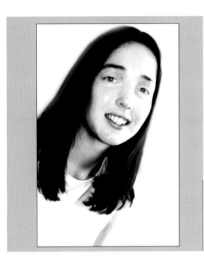

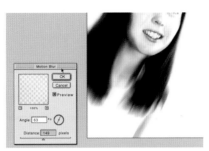

04 For a more dynamic pose the image was rotated and cropped.

06 The image is flattened and the background layer duplicated. I then applied the Motion blur filter to the upper copy of the image and masked the layer so that the face area is hidden.

05 To add a little more impact, I want to add some selective blurring. The first job is to delete the layer mask (drag the mask thumbnail to the trash icon on the layers palette). When asked if you want to apply the mask, click yes.

07 After playing around with the colors in the new layer (and increasing saturation), I altered the 'Blend If' options for the upper layer as shown above (double click on the layer thumbnail to bring up these options). By moving the white slider (circled here in red) whilst holding down the alt key, you can make all highlights in the layer invisible. The alt key lets you make the cut off point gradual, rather than abrupt.

08 A little tweaking of contrast and the image is finished – and it certainly bears little resemblance to the original.

navigator

Photoshop keyboard shortcuts

Transform layer	ctrl-T/⌘-T
Curves	ctrl-M/⌘-M
Hue/Saturation	ctrl-U/⌘-U
Dodge/burn tool	O

Playing with color

Many of the tools found in common image editing applications are designed to correct color problems. The same tools can also be used to dramatically alter the mood of an image in seconds.

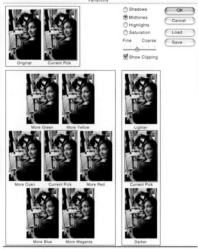

01 This portrait has been scanned from a standard print, with the color corrected at scanning stage.

The shot was taken around midday, a time when the color of light is fairly neutral. Traditionally, photographers have used color filters to add a warm or cool tone to color pictures needing a little atmosphere, something we can easily recreate in software. For this picture, I wanted to create a warm dusky feeling, similar to the effect of a tobacco filter in conventional photography.

02 As with any tonal alteration, there are many different ways to get the effect we're after. As this is a somewhat subjective alteration, I've opted to use Photoshop's Variations command – visually assessing the effect of adding increasing amounts of red and yellow.

03 A tighter crop adds the final touch to a more atmospheric portrait.

technical details
Nikon F90X 35mm SLR
35-70mm f2.8 lens
Fujicolor Negative Film
Microtek ScanMaker 8700

tools
Scanning
Variations
Hue/Saturation
Color Balance

keep in mind
Experiment with levels, curves, hue & saturation and color balance controls, and you will soon discover the wealth of different effects you can produce with simple tools.

Color Balance

04 Try using the color balance control for a quick transformation. Here two very different portraits have been given a blue and cyan boost, with the image below also having its contrast increased for a bolder result.

05 For a quick graphic effect, open the Hue/Saturation window and whack the saturation up to its maximum. This effect works better with bold, graphic images such as this unusual self-portrait. Be careful not to produce unflattering skin tones.

Photoshop keyboard shortcuts
Hue/Saturation	ctrl-U/⌘-U
Color Balance	ctrl-B/⌘-B
Levels	ctrl-L/⌘-L

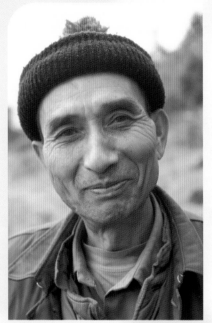

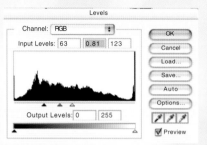

Levels

Channel: RGB

Input Levels: 63 0.81 123

OK
Cancel
Load...
Save...
Auto
Options...

Output Levels: 0 255

☑ Preview

07 Using the levels controls allows more control over the increased contrast (than brightness/contrast).

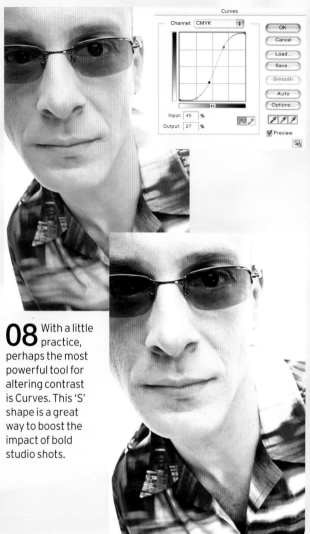

Curves

Channel: CMYK

OK
Cancel
Load...
Save...
Smooth
Auto
Options...

Input: 45 %
Output: 27 %

☑ Preview

06 Although a little too drastic for many portraits, extremely high contrast graphic effects can be remarkably effective for some images.

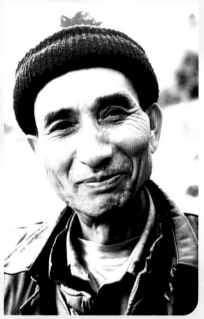

08 With a little practice, perhaps the most powerful tool for altering contrast is Curves. This 'S' shape is a great way to boost the impact of bold studio shots.

Photoshop keyboard shortcuts
Hue/Saturation ctrl-U/⌘-U
Color Balance ctrl-B/⌘-B
Levels ctrl-L/⌘-L
Invert Image ctrl-i/⌘-i

tools
Curves
Levels
Diffuse Glow
Blending modes

keep in mind
Later versions of Photoshop allow you to apply most color changes as an Adjustment Layer – useful if you change your mind.

Solarization effect

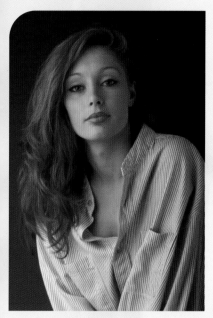

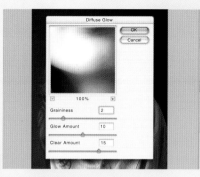

02 Run the Diffuse Glow filter (Filter>Distort>Diffuse Glow) on the upper layer. Try the settings shown in the screen above to start with.

01 First, correct any color and exposure problems. Make a duplicate of the background layer (the one containing the image).

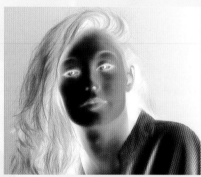

03 Invert the upper layer (Image> Adjust>Invert) to make a negative.

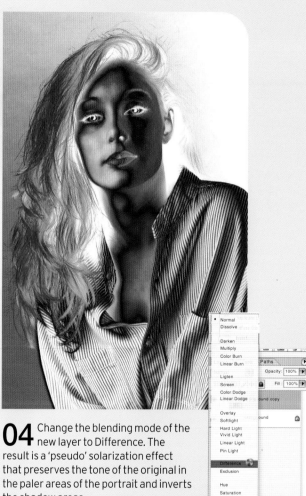

04 Change the blending mode of the new layer to Difference. The result is a 'pseudo' solarization effect that preserves the tone of the original in the paler areas of the portrait and inverts the shadow areas.

navigator
Levels p36
Curves p40
Effects filters p102

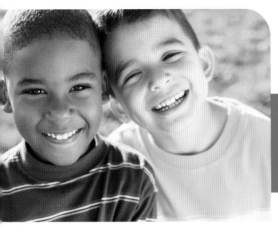

Effects filters

As soon as anyone gets their hands on a piece of imaging software, the first thing they reach for is the Filters menu. Here's a quick guide to a couple that can be useful for the portrait photographer.

01 Effects filters – especially those that alter the image tone or detail dramatically – work better on images with large, bold shapes and solid colors. In this respect, effects filters are actually quite well suited to adding special effects.

Since special effects rarely improve a poor photo, we'll start with a shot that works perfectly well without any digital trickery.

02 One of the most popular filters for portraits is watercolor. I prefer to keep the Shadow Intensity setting at zero to stop over-darkening of the image. Experiment with the settings.

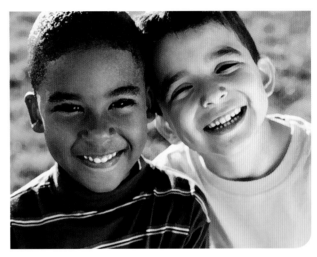

03 Filters that use brushstrokes have a more pronounced effect on lower resolution images, so for this example, I reduced the image size first. You may also need to tweak the brightness after running the filter. Most applications offer a whole range of paint-style effects for you to experiment with.

Effects Filter Tips

■ It is easy to overdo special effects, and some – such as 'Find Edges' – have become to clichéd and it is best to avoid them altogether.

■ Run effects filters on a duplicate layer; this allows you to mask the effect or remove it. By changing the blending mode or opacity of the filtered layer, you can create a whole new set of effects.

■ Dramatic filters and paint effects can help disguise focus problems.

keep in mind
The effect of many filters is reduced as the image file gets bigger (or as the resolution gets higher). If the brush strokes seem too small, reduce the pixel dimensions of the image for a bolder result.

04 Although your subject might not appreciate the results, some portraits are simply perfect for a little distortion. Photoshop's Liquify filter or dedicated applications (ScanSoft Super Goo) offer amazing morphing effects.

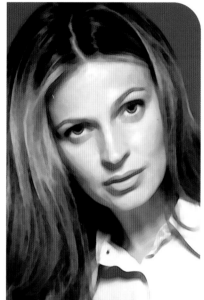

05 The result above was produced using Photoshop's Liquify filter. Try also using the standard distort filters (Spherize, Pinch etc) for comical results.

06 Many filters produce wildly different results depending on the settings you enter in the dialog box. Accented edges (found under Photoshop's Filter>Brush Strokes menu) shows the value of experimenting with the various sliders. With a high Edge Width and Brightness and low Smoothness, the result is pretty hideous.

07 Reducing the edge width to 1 and brightness to 8, and increasing the smoothness produces a much more appealing result. In fact, with a little tweaking the Accented Edges filter can produce some of Photoshop's most realistic and attractive paint effects.

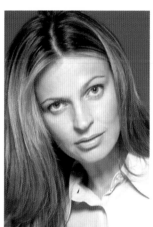

The original image ▶

navigator

Photoshop keyboard shortcuts

Repeat last filter	ctrl-F/⌘-F
Open last filter dialog	ctrl-alt-F/⌘-option-F
Fade last effect applied	ctrl-shift-F/⌘-shift-F
Liquify	ctrl-shift-X/⌘-shift-X

Grain and texture

Adding grain to a photograph can transform its mood and is a great way of adding some much needed organic texture to digitally captured images.

01 We'll start with a contemporary informal studio portrait. The original black and white shot has been toned by converting to RGB mode and using the Hue/Saturation colorize option (see page 78).

02 Most applications offer an 'add noise' filter. If you have the option, choose Gaussian distribution. It is usually preferable to check the Monochromatic option, as this produces a grainy – rather than noisy – result.

03 Photoshop (and most other applications) also offers a Film Grain filter. This has a tendency to bleach out highlight detail and so is a more realistic representation of very high speed film.

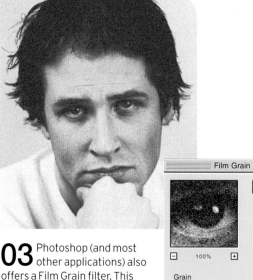

technical details
Canon EOS D-30
EF 100mm F2.0 USM
Adobe Photoshop 5.5

tools
Taking the shot
Scanning

keep in mind
You can buy special textured papers for your inkjet printer. Watercolor and canvas varieties are now commonly available.

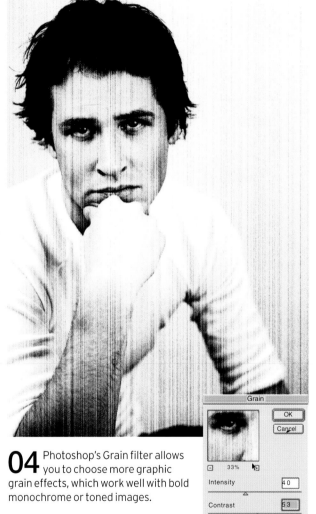

04 Photoshop's Grain filter allows you to choose more graphic grain effects, which work well with bold monochrome or toned images.

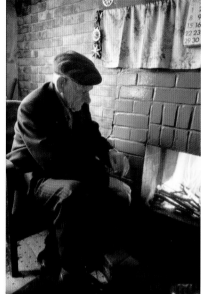

05 Adding grain to digital camera images can bring a welcome organic feeling to the soulless results you can often get straight out of the camera.

06 By combining the Add Noise filter and a sympathetic color balance alteration, the image becomes instantly warmer and the grain adds character.

Texture & Grain tips

■ As with paint filters, the amount of grain you need to add will increase as the resolution of the image gets higher.

■ Resize your image to your intended print dimensions before you apply grain effects; if you print at a reduced size the effect may not be visible.

■ Apply textures and grain filters to a separate layer at the top of your image (see page 107 for details of how to do this). You can then reduce, mask or remove the effect, and you can apply it to multi-layered images.

■ Scan or digitally shoot interesting textures and blend them with your portraits for interesting results.

Adding a paper texture

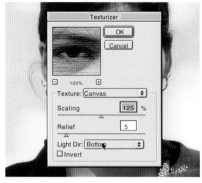

01 Adding a texture to a portrait is an easy way to produce an image that is a little out of the ordinary. There are two basic techniques: The first is to sandwich your portrait with a textured image and play with the blending modes of the two layers. If you use a greyscale texture image and Overlay mode, the result is a color photo that looks like it has been printed onto textured paper.

02 Even easier is to run a texture filter onto the image. These overlay small texture patterns tiled over the entire image. Photoshop's texturizer offers fairly natural looking textures, the best for portraits being 'Canvas'.

03 To produce the image below, I ran the Texturizer filter onto the portrait after placing it in a new layer over a plain white background. A layer mask with a circular gradient was then added to produce the vignette.

keep in mind
Create your own textures for use with the texturizer - simply create a square, greyscale .PSD file and load it using the 'Texture' drop down menu.

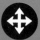

tools
Texturizer
Layer Masking
Add Noise

Making a grain or texture layer

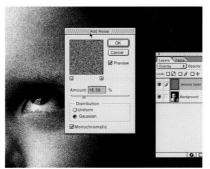

04 Experiment with different blend modes for more dramatic effects.

03 Run the Add Noise filter onto the new layer. This will add grain to the entire image, even if it has many layers (only selected layers are usually affected).

01 If you want to apply a texture effect that is reversible (or to a multi-layered image), you need to create a 'texture layer' on top of your image.

02 Create a new layer, set it's blend mode to overlay and fill it with 50% grey (invisible in overlay mode). Photoshop lets you do all this in a single window if you choose Layer>New Layer.

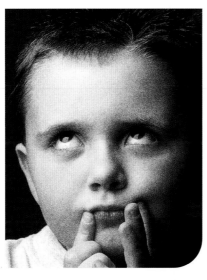

05 A variation on this theme is to sandwich two images – your portrait and a texture – together. The above examples show the same image with a tree bark (blended using Hard Light mode) and brick wall effect (blended using Overlay mode). Using a greyscale texture and Overlay mode produces a textured image with little tonal change.

keep in mind
Effects such as adding texture and grain should not be allowed to detract from the image itself – subtle is always better.

tools
New Layer
Fill
Add Noise
Layer Blending

Multi-layered images

Image editing applications offer powerful tools for combining two or more pictures for montage or collage. Complex multi-layered images can add depth and interest to simple portraits.

input

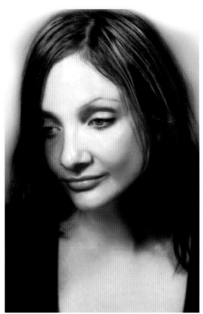

01 Once you have mastered the basic techniques of image enhancement and manipulation, there are no limits to your creative possibilities. By bringing multiple images together with a little thought and a little patience, you can create rich, deeply layered montages and collages which – if you're lucky – add immeasurably to the original portrait. Here, I'm starting with a simple indoor portrait taken using fairly flat lighting (two flash heads) in a corner of my office. Some basic image corrections sorted out the brightness and contrast.

02 The image was then worked on to add some texture, alter the color and saturation, dodge and burn the face and remove most of the background.

03 I then gathered together an assortment of images. Try to maintain some kind of 'theme', either in the subject matter or in the general tonal quality and color of the images.

technical details
Fujifilm FinePix S1 Pro
Digital SLR
90mm F/2.5 Tamron lens
Adobe Photoshop 6.0

tools
Levels
Hue/Saturation
Layer blending
Layer Masking
Layer options

keep in mind
When creating multi-layered images, make life easier for yourself by giving your layers sensible names, rather than the default Layer 1, Layer 2 and so on. A few seconds spent renaming will reap rewards as the layers build up.

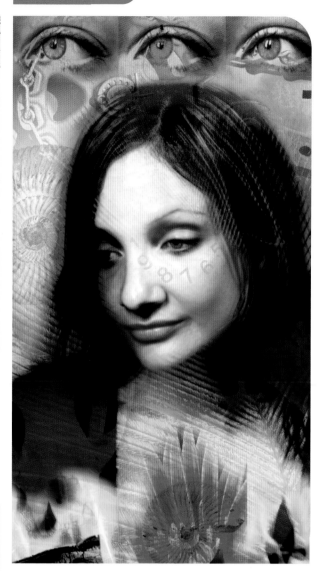

04 Each image was opened and dragged onto the portrait image, each time creating a new layer. The layers were then each treated by either adding masks, changing the opacity or colorizing.

05 To move the layers quicker, click on 'Auto Layer Select' in the move tool options. Now, when you click on an element in the montage, its layer will automatically be selected.

06 The screen shot above shows the final layers palette for the image shown on the right. All the elements shown on the opposite page have been used at least once. The entire composition took around two hours.

Blend if...
Within the Layer options of many applications you will find the 'blend if' sliders. From here you can define whether pixels in a layer are visible or not depending on their brightness. Thus, you can remove all white pixels in a layer by sliding the white arrow to the left as shown here – useful for quickly cutting out objects on a white background. Hold down the alt (option) key whilst moving the slider to make the cut off point a smooth gradient.

keep in mind
Projects such as this require the three 'P's' – planning, patience and practice. With a little experimentation you should soon be producing your own masterpieces!

Glossary

A

Aperture · Variable opening that controls the amount of light that passes through the lens.

Analogue · Continuously variable.

Anti-aliasing · Smoothing the jaggy edges of selection or paint tools in digital imaging applications.

B

Bit · A binary digit, basic digital quantity representing either 1 or 0. The smallest unit of computer information.

Bitmap · [1] An image made up of dots, or pixels. [2] A color mode in Photoshop where every pixel is either black or white (no greys or colors).

Byte · Standard computer file size measurement: contains eight bits. Other common units include Kilobyte (K: 1024 bytes), Megabyte (MB: 1024K) and Gigabyte (GB: 1024 MB).

C

CCD · A Charged Coupled Device (CCD) converts light into electrical current. The digital camera equivalent of film.

CMY, CMYK · (Cyan, Magenta, Yellow). Color printing model used by dye-sub and low-end inkjet printers. CMYK adds black (Key) and is used for most professional printing. Most modern photo printers add pale Cyan and pale Magenta inks for improved pastel tones.

Color Bit Depth · The number of bits used to represent each pixel in an image; the higher the bit depth, the more colors appear in the image:

1-bit color = black & white image with no greys or colors;

8-bit color = 256 colors or greys;

24-bit color = 16.7 million colors ('photorealistic' color).

Compact Flash · Type of removable media for digital cameras.

Compression · The 'squashing' of data to reduce file size for storage or to reduce transmission time. Compression can be 'lossy' (such as JPEG) or 'lossless' (such as TIFF LZW). Greater reduction is possible with lossy compression than with lossless schemes.

Cropping tool · A tool found in image editing software that allows you to trim an image.

D

Data · The generic name for any information used by a computer.

Digital Zoom · Camera feature involving enlarging the central part of an image to give a similar effect to a telephoto lens (in fact, is simply a crop). This usually results in a drop in image quality.

Dithering · A method for simulating many colors or shades of grey with only a few.

Dpi · (Dots per inch) A measurement of the resolution of a printer or video monitor (see also **ppi**).

Driver · A software utility designed to tell a computer how to operate an external device (i.e. a printer).

E

Exposure · The amount of light falling on the CCD of a Digital Camera or the film in a conventional camera. Exposure is determined by the combination of shutter speed (duration) and aperture (intensity).

Exposure Compensation · The ability to increase or decrease the exposure set by the camera's automatic system.

F

Feathered Edge · Soft edge to a mask or selection. Allows seamless montage effects.

File Format · The way that the information in a file is stored. In digital photography, common file formats include JPEG, TIFF and GIF.

Filter · Photo editing software function that alters the appearance of the image being worked on, much like the physical filters that can be put on the front of camera lenses.

Focal Length · The attribute that determines the magnification and field of view of a lens.

Focus · Adjusting a lens so that the subject is recorded as a sharp image.

Flash memory · A type of fast memory chip that remembers all its data even when the power is turned off. Used in most digital camera cards.

G

GIF · A graphic file format developed for exchange of image files (only supports 256 colors).

Grey Scale · What photographers would call a black and white image. It contains a range of grey tones as well as black and white.

H

Hue/Saturation · An RGB image can also be defined by Hue, Saturation and Brightness, where Hue is the color and Saturation the 'strength'. Hue/Saturation controls are useful for altering colors without effecting overall brightness or contrast.

I

Image Manipulation · Once a digital image has been transferred into a computer, image manipulation software allows the individual pixels to be altered in many ways. Color corrections, sharpening, photomontage and distortions are all forms of manipulation.

Interpolation · Increasing the number of pixels in an image or filling in missing color information by averaging the values of neighbouring pixels (basically using an educated guess). This 'upsampling' cannot add detail or information but is used by most digital cameras when recording images.

J

Jaggies · The jagged stepped effect often seen in images whose resolutions are so low that individual pixels are visible.

JPEG · A file compression standard that is capable of very high level of compression, but is a 'lossy' method and so can degrade image quality. JPEG allows you to choose the level of compression (and thus the level of quality loss).

L

LCD monitor · A small color screen found on many digital cameras that allows previewing/ reviewing of images as they are taken.

M

Mask · In digital imaging an 8-bit overlay, which isolates areas of an image prior to processing. A mask is used to define an area of an image to which an effect will be applied. Often called a selection.

Megapixel · One million pixels; a measure of camera resolution.

Marquee · Outline of dots created by an image editing program to show areas selected for manipulation, masking or cropping.

Magic Wand · A selection tool that automatically selects areas of continuous color around the point where it is clicked. The tolerance setting defines how near a color must be to be included in the selection.

N

Noise · Unwanted electrical interference that degrades analogue electrical equipment. In digital cameras, this most often occurs in very low lighting or shadow areas in the form of pixels of the wrong color appearing at random in dark areas.

O

Optical Resolution · In scanners, the maximum resolution possible without resort to interpolation. Also used to describe a digital camera's true CCD resolution.

P

Photosite · A single photosensitive element in a CCD that translates to one pixel in the resultant image. Also known as a CCD Element.

Photoshop Plug in · A small piece of software that adds extra features or functions to Adobe Photoshop or other compatible applications.

Pixel · (PICture ELement) The smallest element of a digitized image. Also, one of the tiny points of light that make up a picture on a computer screen.

Ppi · Pixels/points per inch. A measure of the resolution of scanners, digital images and printers.

R

Removable Media · Small memory chips, which store the captured images.

Resample · To change the number of pixels in an image. Upsampling uses interpolation to increase the number of pixels. Downsampling throws away pixels to reduce the size.

Resize · Changing the resolution or physical size of an image without changing the number of pixels. For example a 2x2" image at 300dpi becomes a 4x4" image at 150dpi. Often confused with Resampling.

Resolution · Measure of the amount of information in an image expressed in terms of the number of pixels per unit length (i.e. pixels per millimeter or pixels per inch). Camera resolution is usually defined as the actual number of pixels in an image (i.e. 640x480) - see **dpi** & **ppi**.

RGB · Red, Green and Blue. TVs, monitors and digital cameras use a mix of R,G & B to represent all the colors in an image.

S

Saturation · The amount of grey in a color. More grey means lower saturation. See also **Hue/Saturation**.

Selection · An area of an image isolated before applying an effect.

T

Telephoto lens · Lens that has the effect of making subjects seem closer than they actually are.

Thumbnail · A small, low-resolution version of a larger image file that is used for quick identification and for displaying many images on a single screen.

TIFF · The standard file format for high-resolution bitmapped graphics.

UVW

Unsharp Masking · A software feature that selectively sharpens a digital image in areas of high contrast whilst having little effect on areas of solid color. The effect is to increase the apparent detail and sharpness.

XYZ

White Balance · In digital camera terms, an adjustment to ensure that colors are captured accurately (without any 'color cast') whatever the lighting used. This can be set automatically, using presets for different lighting types or measured manually.

Wideangle lens · A lens of short focal length giving a wide angle view, allowing more of a scene to be fitted into a photograph.

Zoom Lens · Variable focal length lens that allows the user to adjust his field of view ('zoom in or out').

Acknowledgments

I would like to thank the photographers whose work appears throughout this book, the friends and family who have agreed to act as models over the last fifteen years, and the staff at Rotovision and S2 Creative Solutions, without whom it would have been an infinitely more difficult job.

Thanks also to the many people working for manufacturers of digital imaging products who kindly loaned equipment for the production of this book, including Adobe UK, Fuji Photo Film UK, Nikon UK and Olympus UK.

Finally, I must thank Claire for her continuing support in everything I do.

Simon Joinson

PICTURE CREDITS

PAGE 89 © Peter Adams

PAGES 55, 73 © Aaron Anderson

PAGES 9, 22, 58, 88 © Nigel Atherton

PAGES 3, 5, 6, 9, 10, 13, 26, 50, 60, 64, 92, 94, 95, 99, 107 © James Cumpsty

PAGES 12, 82, 100 © Steve Davey

PAGES 10, 14, 21, 22, 44, 100, 103 © Digital Vision

PAGES 13, 27, 46, 52, 56, 60, 105 © Angela Hampton

PAGE 96 © Doug Harman

PAGES 9, 11, 12, 13, 17, 26, 32, 33, 34, 35, 36, 37, 43, 45, 68, 69, 72,
 73, 74, 75, 76, 77, 84, 85, 89, 98, 99, 108, 109 © Simon Joinson

PAGES 13, 26, 38, 99, 106 © Becky Moss

PAGE 42 © Vincent Oliver

PAGES 8, 11, 30, 40, 41, 65, 67, 90, 102, 107 © Photo Disc

PAGES 10, 16, 18, 23, 27, 45, 62, 66, 78, 101, 103 © Chris Rout

PAGES 13, 35, 70, 71, 104 © Stephen Sainsbury